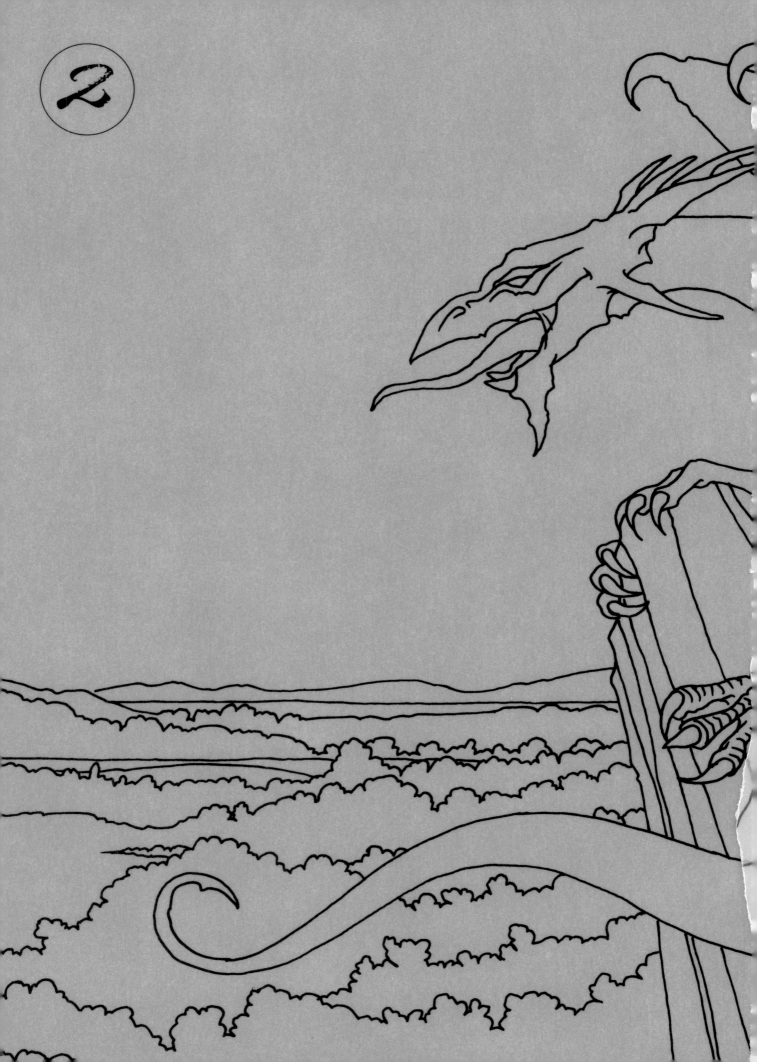

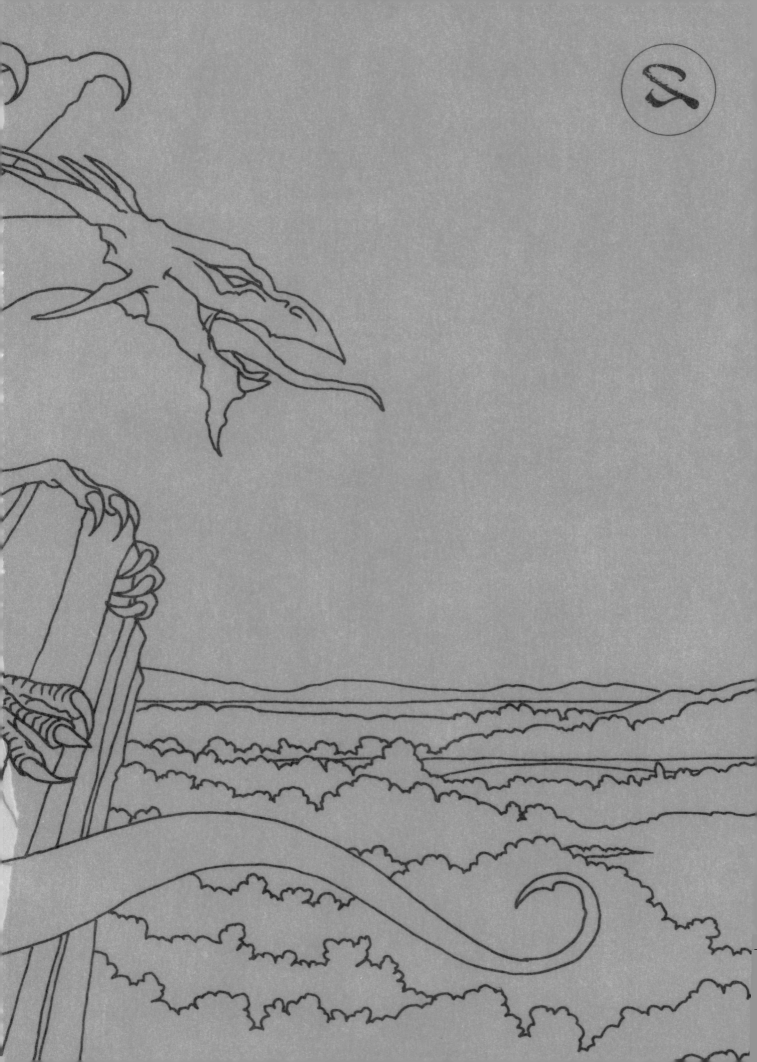

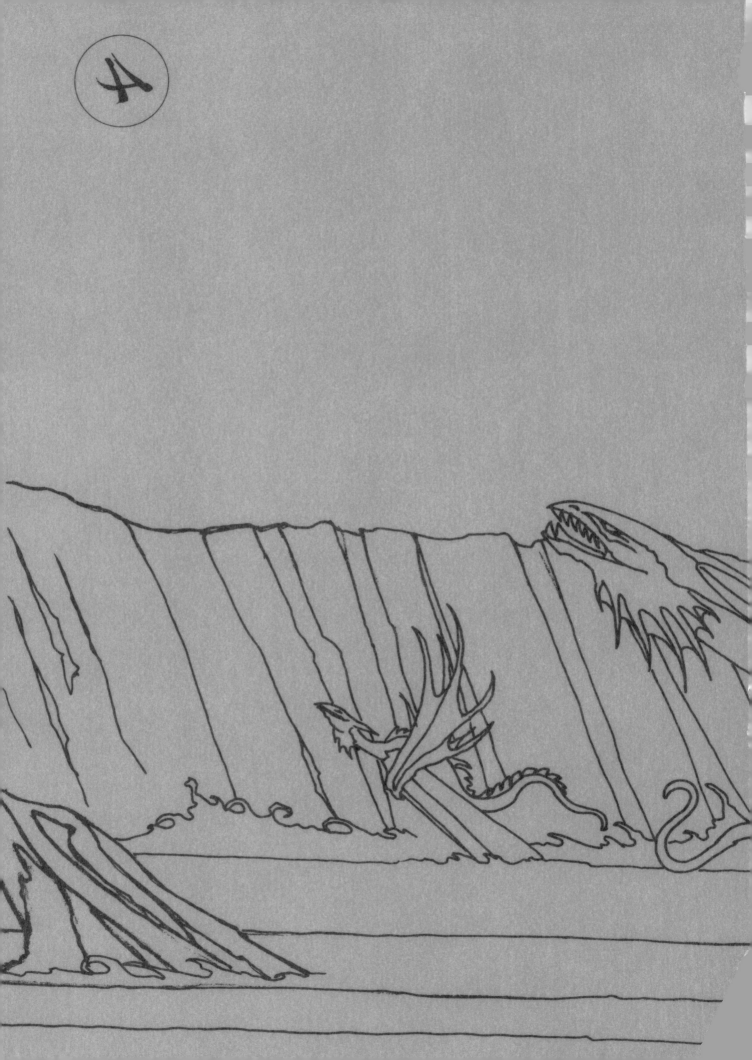

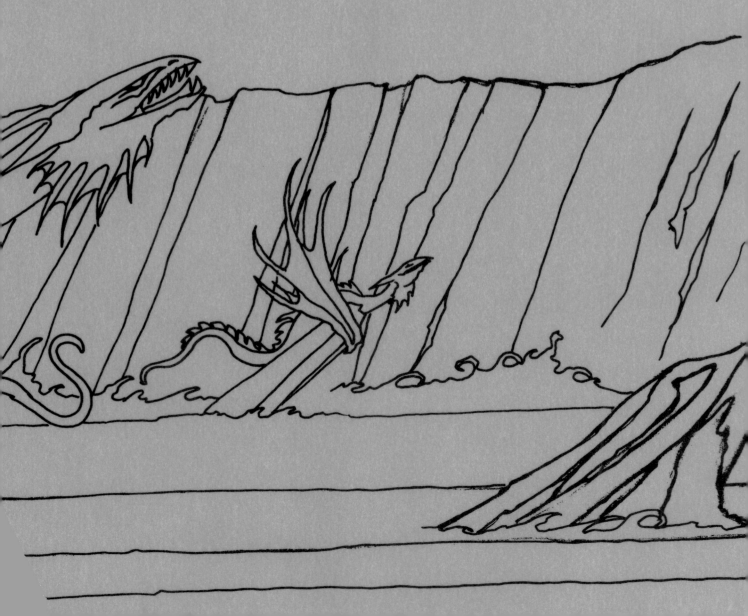

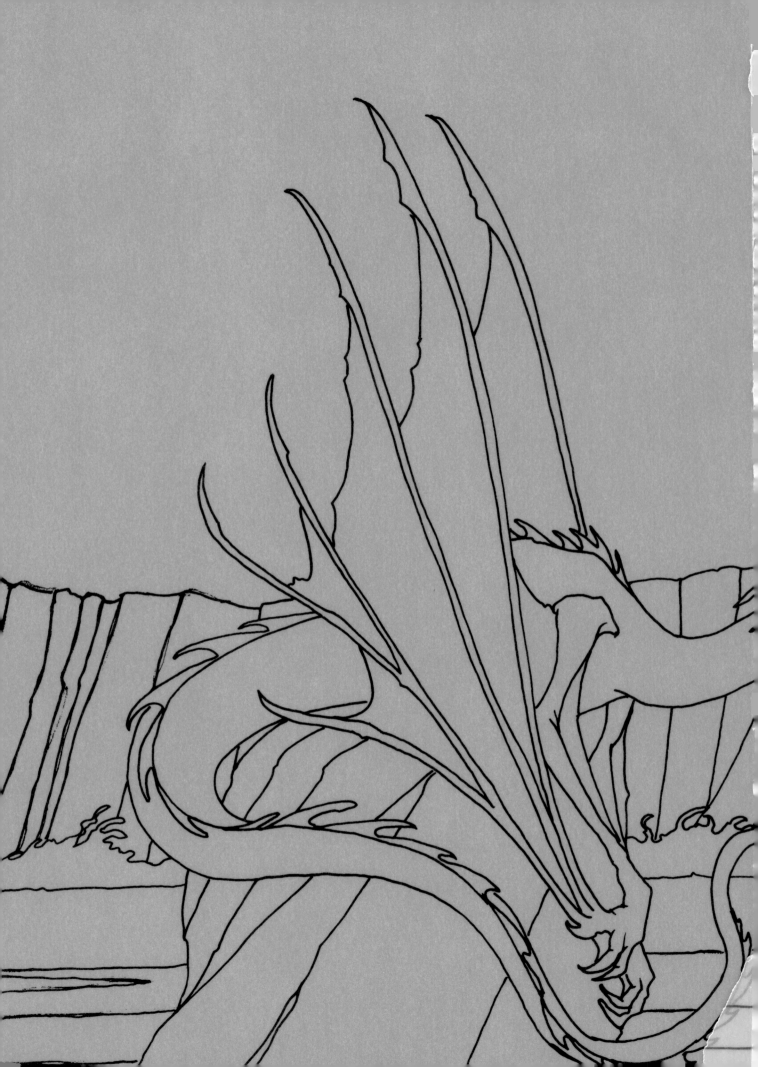

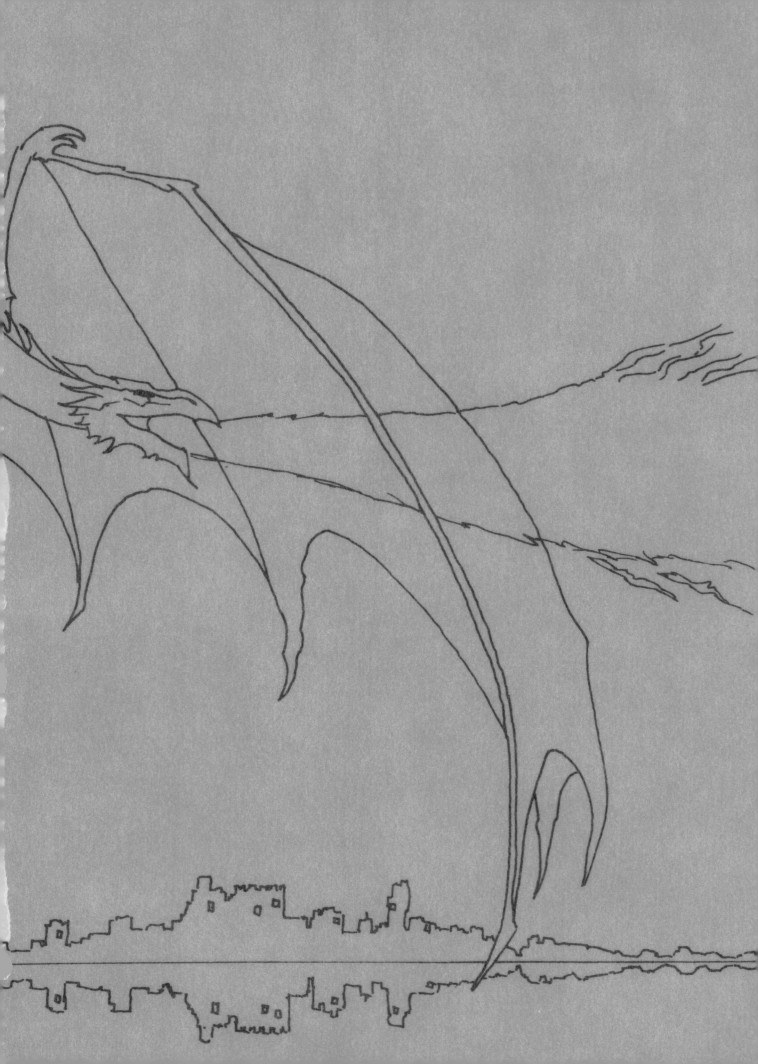

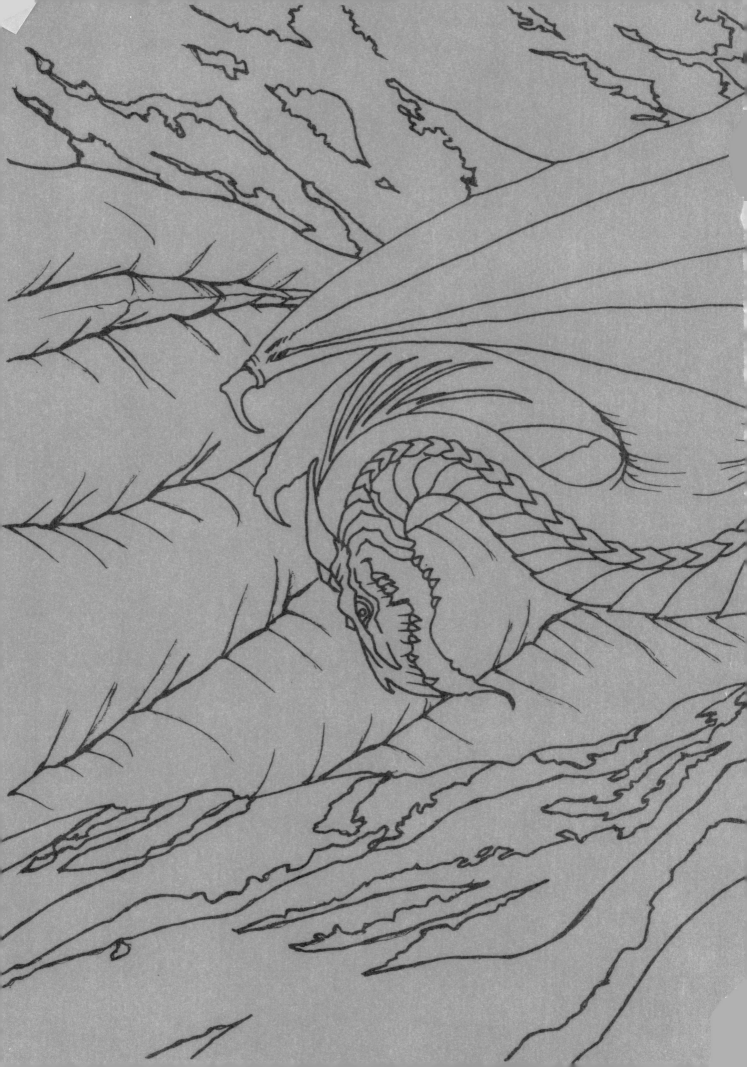

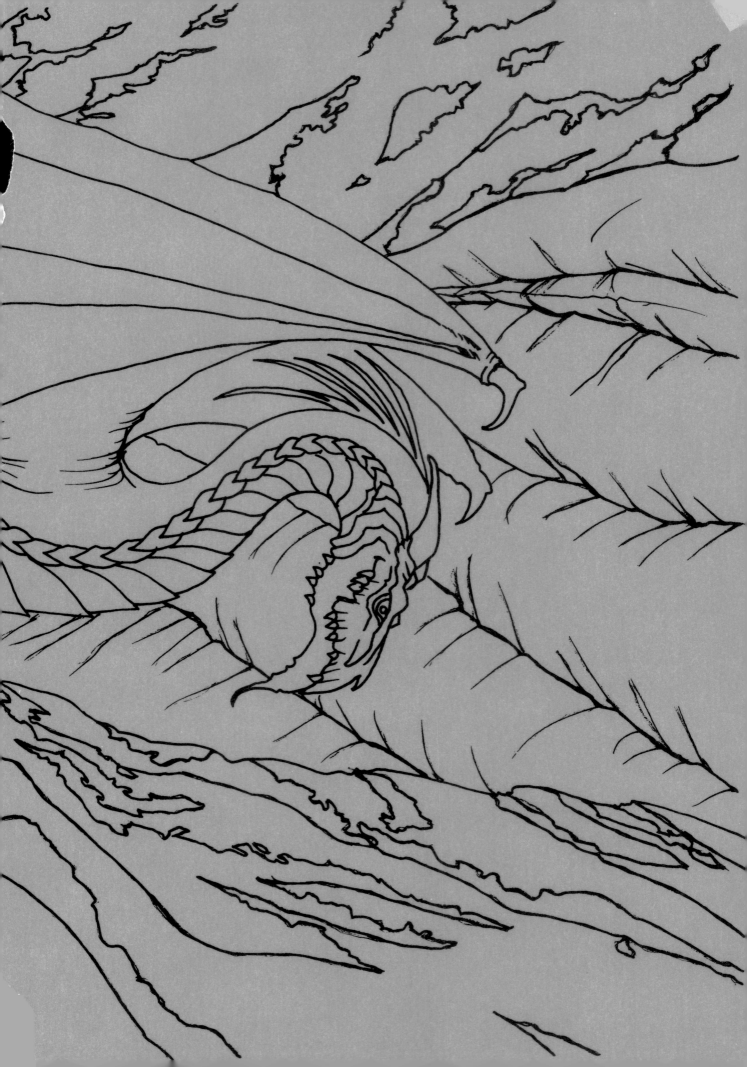

READY TO PAINT

DRAGONS

MARC POTTS

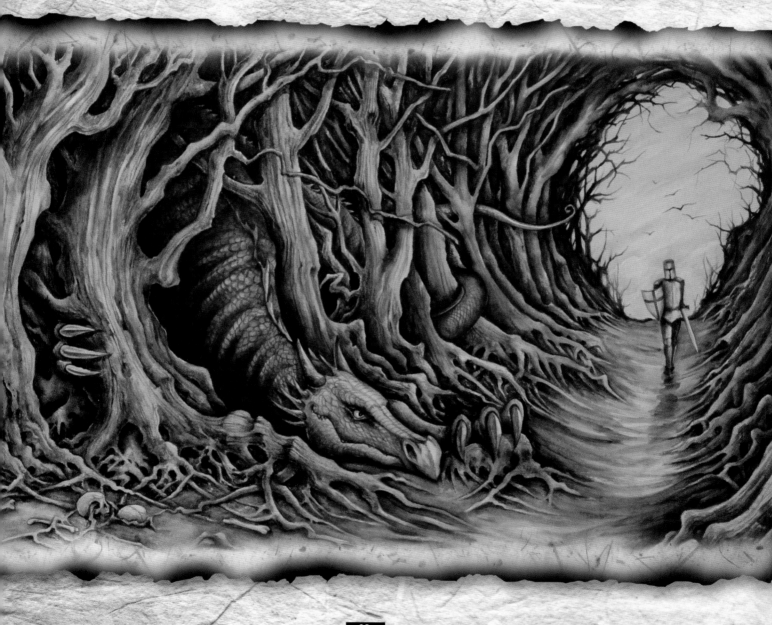

SEARCH PRESS

First published in Great Britain 2011

Search Press Limited
Wellwood, North Farm Road,
Tunbridge Wells, Kent TN2 3DR

Text copyright © Marc Potts 2011

Photographs by Debbie Patterson at Search Press Studios

Photographs and design copyright © Search Press Ltd 2011

ISBN: 978-1-84448-632-8

Suppliers
If you have any difficulty obtaining any of the materials and equipment mentioned in this book, please visit the Search Press website: www.searchpress.com

Publisher's note
All the step-by-step photographs in this book feature the author, Marc Potts, demonstrating his acrylic painting techniques. No models have been used.

Please note: when removing the perforated sheets of tracing paper from the book, score them first, then carefully pull out each sheet.

Printed in China

DEDICATION
Dedicated to my girls... Kelly, Carys, Willow and Mimi

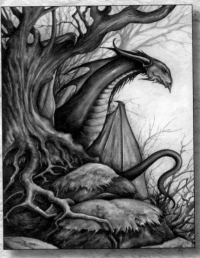

ACKNOWLEDGEMENTS
Thanks to my editor Edd, thanks to the photographer Debbie, thanks to Juan for the design, and of course, Roz Dace.

Page 1
St. George and the Dragon
37.5 x 23.5cm (14¾ x 9¼in)

My rendition of the legendary conflict.

Above
Gorgon
23 x 36cm (9 x 14¼in)
The terrible beast emerges from the woods.

Opposite
The Hedgerow Dragon
37.5 x 25.5cm (14¾ x 10in)

Not all dragons are huge ...

Contents

INTRODUCTION

Dragons are a popular fantasy art subject, cropping up in all manner of paintings in a variety of styles. This is not surprising really, as dragon mythology and folklore is found all over the world in many cultures, and dragons turn up in books, films and art from Tolkein to Disney. Dragon mythology gives us plenty of food for thought and inspiration to create images of these iconic fantasy creatures.

Dragons can be almost any size, from very small to truly cosmic in proportions. They can be winged or flightless, friendly and whimsical or devastatingly hostile. Some are snake-like and have no legs, others might have two, four or even six legs! Dragons are basically reptilian in appearance, often with scaly skin, sometimes with horns or dorsal spines, and pretty much always with claws and fangs.

Creating what does not exist can present a number of problems. I use all kinds of visual references for textures, shapes and colour. Bats are an obvious place to look for wing structure, and ideas for drawing dragons can be developed by looking closely at other animals, such as reptiles, birds and mammals – or even beyond the animal kingdom, to bits of wood! Anything that sparks the imagination is valid, and although there is an obvious, 'standard' look to a dragon, precisely because they do not exist, anything goes! I am a great believer in this kind of approach, when developing a creature or character, as it can take your idea up and away from the ordinary.

That said, I have tried to keep the dragons in this book relatively simple and mostly quite traditional in look. I have tried to suggest size and power and placed them in a variety of habitats, from a volcanic lava field to the sheer frozen cliffs of an icy mountain. In the extra paintings in this book I have shown a few different styles, with varying levels of detail, from a small insect-eating hedgerow dragon, to a huge hilltop dragon, complete with trees growing from its back.

I hope you enjoy painting and experimenting with the dragons in this book and they inspire you to go on and create more!

Guardian
42 x 30cm (16.5 x 11.75in)

This painting shows a mighty blue dragon guarding a tower in an ancient forest.

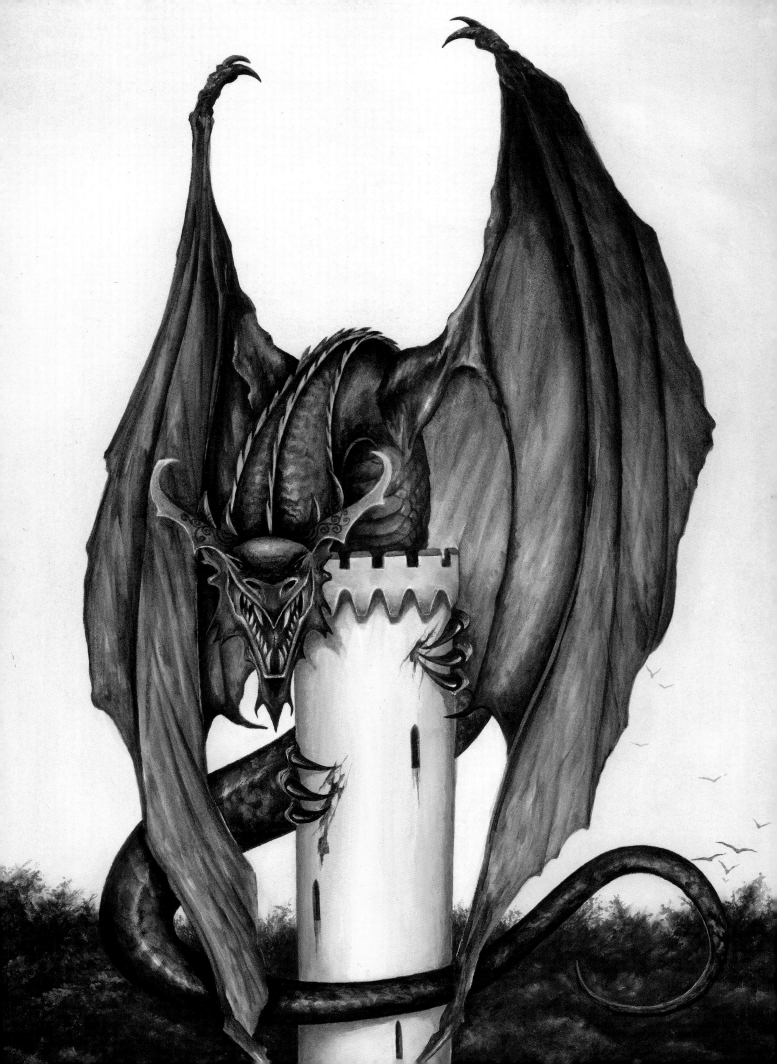

Materials

Paints

All of the pictures in this book have been completed in acrylics, some with an almost oil painting-like style, others with a very watercolour-like approach. Personally, I like to build up semi-translucent layers of colour. One advantage of acrylics over watercolour is that the layer beneath is 'locked' if properly dry. Painting wet-in-wet will make the paint behave more like watercolour, but sometimes you have to work quickly!

All in all, acrylics are a fantastic and versatile medium, that lend themselves very well to fantasy art, and dragons are no exception to this.

I do not stick to one kind of paint, but I do use good-quality acrylics, with good, pure pigment. For the most part I use Daler-Rowney Cryla paints, from the Artists' Acrylics range. I also use Old Holland's New Masters Acrylics. The latter are well known for their fantastic quality oil paints, and their acrylics are just as good. Both ranges provide a good range of colours with excellent pigmentation.

A variety of acrylic paints in tubes.

Surfaces

Acrylic paints can be used on all sorts of surfaces and in many different ways; primed hardboard or canvas panels are great, as is decent heavy watercolour paper.

I prefer Daler-Rowney watercolour board mounted with Saunders-Waterford paper. It saves stretching paper and comes in a variety of surfaces. For the projects in this book I have used the mid-range textured Not board. This board can take repeated washes or layers and some quite harsh drybrushing (but note that it is not indestructible!)

Watercolour board.

Brushes

I use the Pro Arte Acrylix range of brushes, which are designed to be used with acrylic paints. I use a lot of fine 000 brushes (and ruin loads!) as well as series 204 flat brushes. I also occasionally use large wash brushes.

Like all artists, I have amassed a huge collection of brushes in varying degrees of disintegration. I find all of them are still useful for certain particular tasks, so I keep them. In actual fact, sometimes old brushes work well, and take on a particular character as they wear out. For this reason, I advise you to keep your brushes until they really are positively of no use any more.

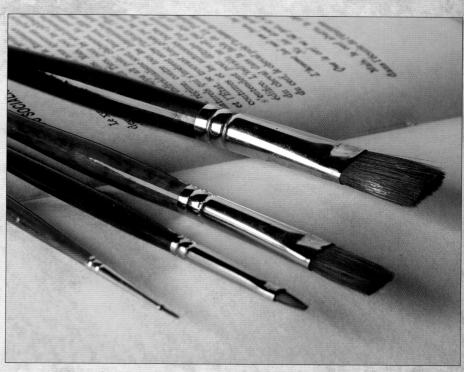

The brushes used in this book. From top to bottom: 15mm (³/₄in) flat, 10mm (³/₈in) flat, 3mm (¹/₈in) flat, size 000 round.

Other materials

Stay-wet palette This is an invaluable item as it keeps acrylics usable for days. Once out of the tube, acrylics will dry to a hard, waterproof plastic and be unusable, but with this, the paint sits on a membrane sheet over a reservoir sheet, like blotting paper. This keeps the paints wet, as long as you remember to keep the lid on when not using it!

Water pot I always have several on the go for cleaning brushes and one kept clean for wetting the surface when the wet-in-wet technique is required.

Pencils Any decent pencil will do, although I do have a preference for Staedtler. I use a pencil extender when my pencils get really short through sharpening, a great tool for getting more out of a pencil.

Eraser A decent eraser should always be on hand. Putty rubbers are also useful as they can be shaped.

Ruler A useful tool for helping to draw straight lines for horizons, picture borders, and the like.

Craft knife I prefer to sharpen my pencils with a craft knife, and you can use the same craft knife to cut erasers to the shape you want.

Masking tape I like to mask the borders of my paintings, although this is optional and not required if you prefer to paint right up the edge. Masking tape is suitable for this, as long as it is not left on too long, in which case it can damage the surface when you remove it. Low-tack masking tape or sheets can also be used. Good art suppliers will be able to provide you with this.

Kitchen paper I use normal kitchen paper to wipe brushes clean and take off excess water.

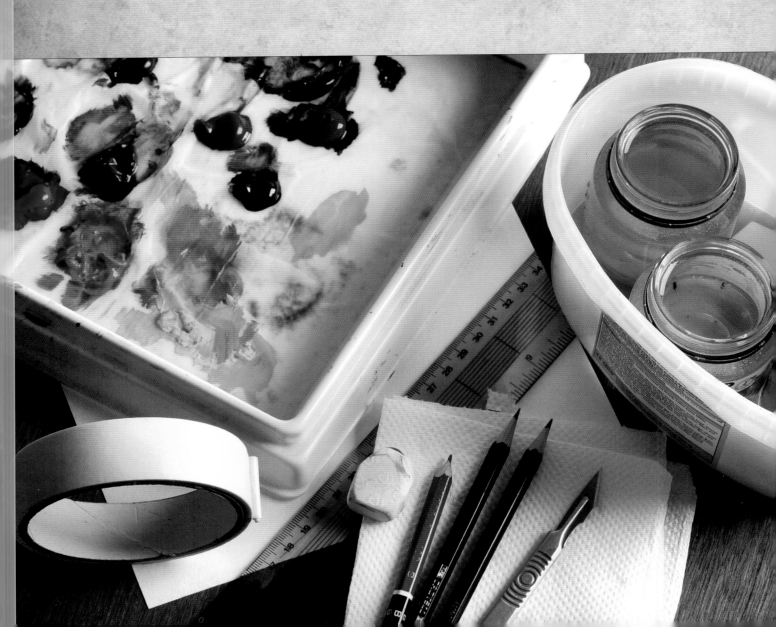

Transferring the image

It is very easy to pull out a tracing from the front of this book and transfer the image on to watercolour board. You should be able to reuse each tracing several times if you want to create different versions of the scene.

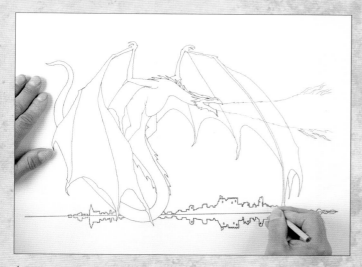

1 Run your pencil carefully over the reverse of the tracing with a soft pencil, such as a B or F.

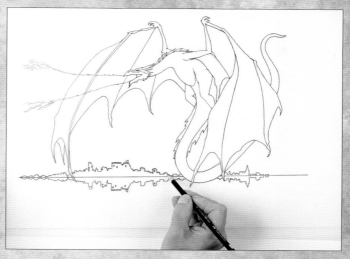

2 Turn the tracing right side up and place it face up on your watercolour board. Use a hard pencil, like a 2H, to go over all the lines of the tracing. If you are right-handed, work from left to right so as not to smudge what you have already drawn, and vice versa if you are left-handed.

3 Lift up the tracing and you will see the drawing beginning to appear on the watercolour board. Do not worry if it looks faint; if it is too strong, the graphite can smudge during the painting process and look untidy. Once the pencil marks are transferred, remove the tracing. You are now ready to paint!

Stormbringer

*T*his painting was inspired by an old English folktale called *The Laidly Worm of Spindleston Heugh*. I like the idea of a dragon conjuring a storm to herald its coming. The normal-looking landscape implies that this dragon could be somewhere here and now!

TRACING
2

You will need

Watercolour board 76 x 60cm (32 x 23½in)

Colours: green umber, sap green, cadmium yellow deep, raw umber, titanium white, buff titanium, permanent rose, Payne's grey, ivory black, rich transparent red oxide, cadmium red deep

Brushes: 3mm (⅛in) flat bright, 10mm (⅜in) flat, size 000 round, 15mm (¾in) flat

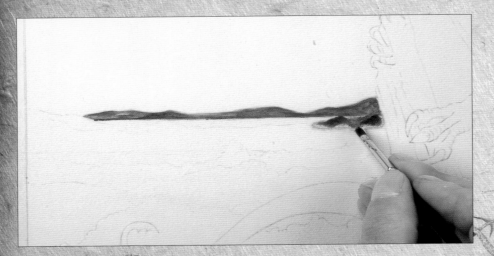

1 Transfer the image following the instructions on page 9, then run masking tape around the edges to create a border. Prepare your palette with the following colours: green umber, sap green, cadmium yellow deep, raw umber and titanium white. Using a 3mm (⅛in) flat bright, begin to paint in the distant hills on the horizon at the lower left with a mix of green umber and a touch of titanium white. Once you have worked over the horizon line, move forward a little, and use the same colour with a slightly circular scrubbing and dabbing motion to begin to put in the distant treetops.

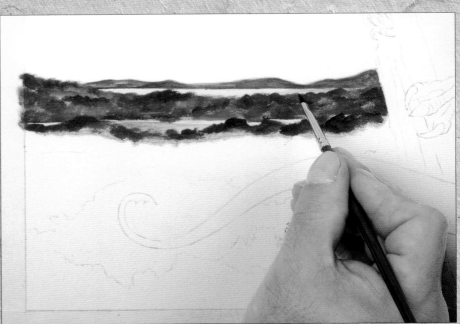

2 Continue adding the distant treetops with the same mix, varying the tone by adding more or less titanium white to the green umber. Leave a few gaps of clean board as you advance to represent pools of water, then dilute some of your mix and add a touch of raw umber. Gently brush on the new mix in horizontal strokes to represent reflections in the water.

3 Continue to advance, developing the mid-level foliage in the same way, using larger circular motions as you get closer. Paint in some areas with a slightly diluted mix to create lighter areas and definition, and introduce sap green towards the front to lighten the tone in areas.

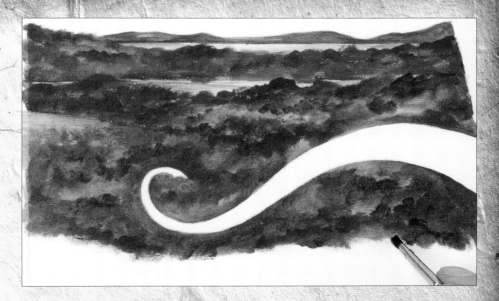

4 Fill in the remaining space with a fairly dilute mix of green umber and sap green, using still larger circular motions. Start to lay in a stronger mix of the colours over the top.

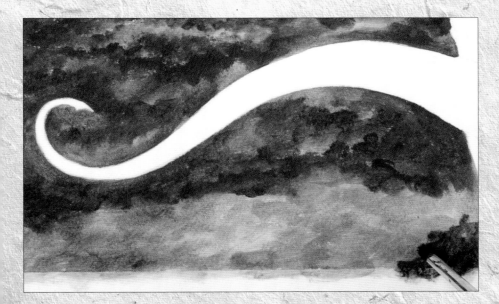

5 Continue filling in the area with the darker mix, then use a stippling motion to dab on touches of cadmium yellow deep to represent sunlight on the topmost leaves of the forest canopy.

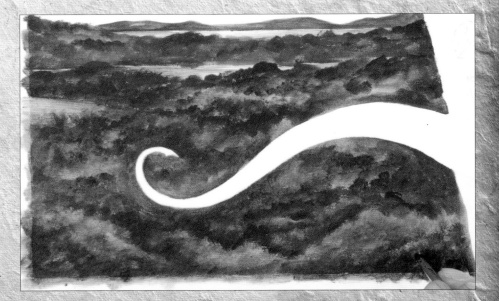

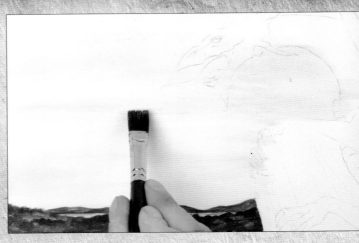

6 Prepare your palette with buff titanium, permanent rose, Payne's grey and titanium white. Wet the board above the forest with a 10mm (⅜in) flat and lay in a dilute wash of buff titanium.

7 Continue working the wash upwards underneath the neck of the dragon, drawing the blade of the brush across the sky occasionally to begin to develop the cloud structure.

8 Working wet-in-wet, continue until you have filled the sky completely with the buff titanium wash, making it slightly less dilute as you come to the top of the page. Allow the paint to dry completely.

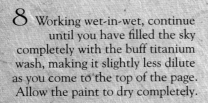

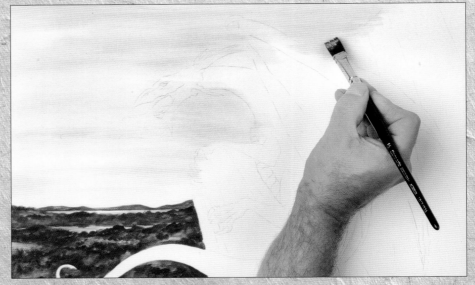

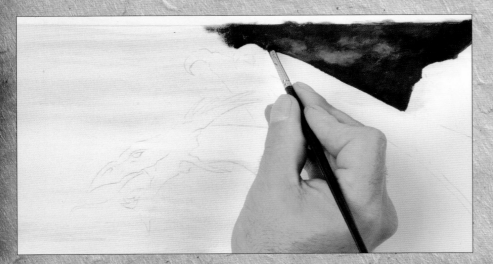

9 Switch back to the 3mm (⅛in) flat bright and begin to suggest the stormclouds in the sky. Starting at the top right, use a fairly dry, strong mix of Payne's grey with a gentle circular scrubbing motion to suggest the roiling clouds. Vary the tone by adding tiny touches of titanium white.

10 Continue working to the left, adding in very small enclosed areas (such as between the dragon's wings) with a size 000 detail brush. Work the dark mix right across the top of the painting, then begin to blend in another layer beneath, this time with more titanium white added and also touches of permanent rose in the mix.

11 Dilute the mixes still further as you work below the last cloud layer, and start to work more horizontal than circular strokes as you descend. Add some rough, random touches of permanent rose and buff titanium to blend the cloud layers together.

Tip

If any rough areas develop, you can blend them back with a touch of dilute titanium white worked into the surface with small circular motions of a small flat bright brush.

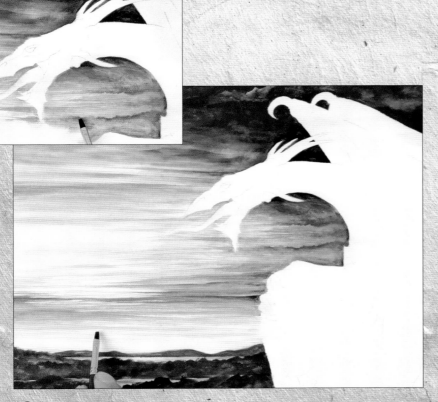

12 Work down towards the horizon with very dilute washes of the same colours, using the 10mm (⅜in) flat brush. Keep the mixes slightly stronger in the area encircled by the dragon's head and neck (inset). On the horizon itself, use pure but dilute permanent rose.

13 With the sky in place start to paint in the rocks beneath the dragon. Use the blade of the 3mm (⅛in) brush to draw a fairly strong mix of raw umber and ivory black up one of the lines of the tracing. Wet your brush slightly and draw the colour out to the right with the flat of the brush, creating a gradient.

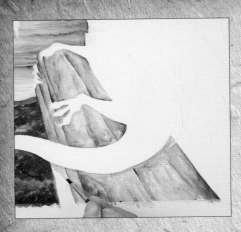

14 Continue to build up the rest of the crag on which the dragon perches, switching to the size 000 round for hard-to-reach areas, and varying the proportions of ivory black and raw umber in the mix. Keep the brushstrokes following the nearly vertical shape of the rocks.

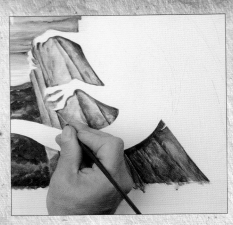

15 Strengthen the areas of the crag that lie in shadow by adding a little more ivory black to the mixes and repeating the process.

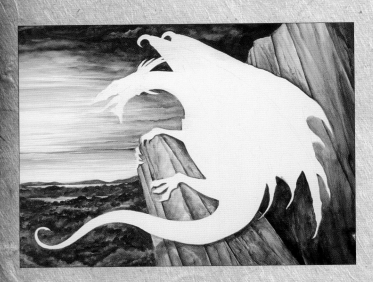

16 Add in some tiny details, such as the shadows of the dragon's claws with a third layer, then use stronger, darker mixes to paint the rest of the rocky outcrop in the same way as the main part. Ensure the section directly beneath the dragon's wing is very dark. You can use a larger 15mm (¾in) flat for this larger section, switching back to the 3mm (⅛in) flat bright for details and hard-to-reach areas.

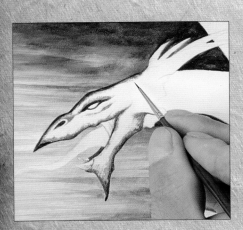

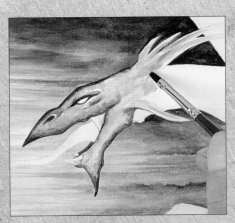

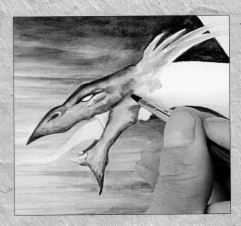

17 Prepare some sap green, raw umber, rich transparent red oxide and ivory black. Add a little water to pure ivory black and use the size 000 round to line the features on the dragon's head, bleeding the colour in from the edges a little.

18 Switch to rich transparent red oxide and use the 3mm (⅛in) flat bright to add an initial undercolour to the head, concentrating on the upper and front parts of the face.

19 Add a touch of raw umber to sap green. Apply it fairly strongly in patches to the top of the head, then dip your brush quickly in water to remove the excess paint. While the paint is still wet, use your damp brush to blend in the colour over the head.

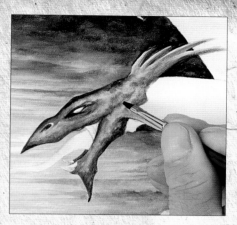
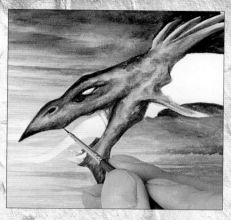
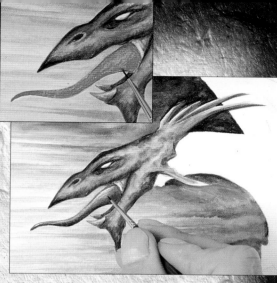

20 Continue applying the sap green and raw umber mix as a glaze over the rest of the head, letting some of the rich transparent red oxide and ivory black show through to create variety and interest. Leave the spiny protrusions at the back of the skull fairly pale.

21 Soften some ivory black with raw umber and use the size 000 round to strengthen the details on the head, particularly around the nostril and the mouth, adding in the webbing and texture of the 'lips' by subtly flicking an almost clean brush upwards from inside the dragon's mouth.

22 Paint the dragon's tongue with cadmium red deep (see inset), then enrich the colour with a glaze of rich transparent red oxide on the underside and towards the back of the dragon's maw. Still using the size 000 round, add a highlight of pure titanium white.

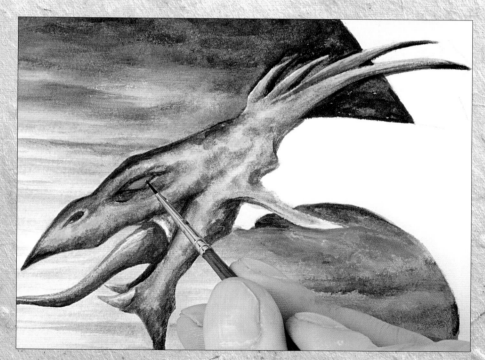

23 Darken and tidy the spines at the back with glazes of sap green and ivory black, then paint the eye in with cadmium red deep.

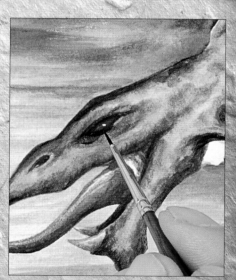

24 Add some very fine glazes of ivory black to the eye to deepen it, then allow to dry thoroughly before adding a tiny highlight of pure titanium white.

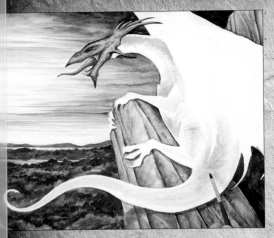

25 Switch to the 3mm (⅛in) flat bright and add some areas of rich transparent red oxide to the main body of the dragon to establish some undercolour.

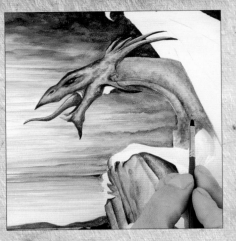

26 Mute some sap green with a little raw umber, then lay it in fairly strongly over the neck around and over some of the red, aiming for a mottled effect to suggest scaly skin.

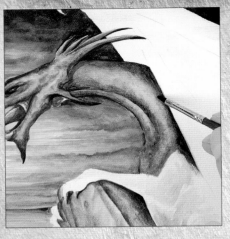

27 While the paint is still damp, reinforce the shading with a dilute mix of ivory black and raw umber, paying particular attention to the large corded muscle in the neck and under the wing.

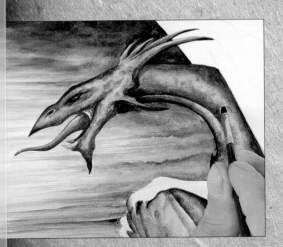

28 Tidy up the details with a size 000 round and the same mix, then use the 3mm (⅛in) flat bright to dab on very dilute sap green to strengthen the mottled effect.

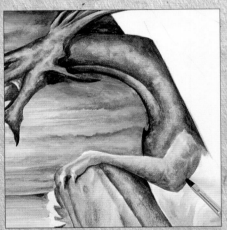

29 Paint the foreleg with the dappled sap green and raw umber mix, leaving some clean white board at the top as a highlight.

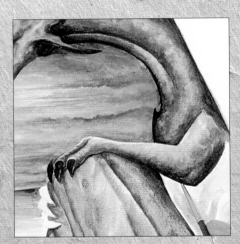

30 While the paint is still damp, switch to the size 000 round and feather dilute ivory black upwards from the underside of the leg to avoid a hard line. Paint in the claws with a stronger mix of ivory black.

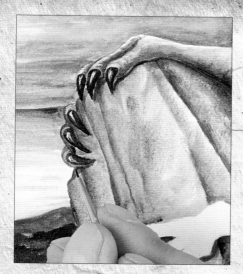

31 Still using the size 000 round, add stark highlights of titanium white to the claws, then paint the paw and claws of the other foreleg that are showing round the rock.

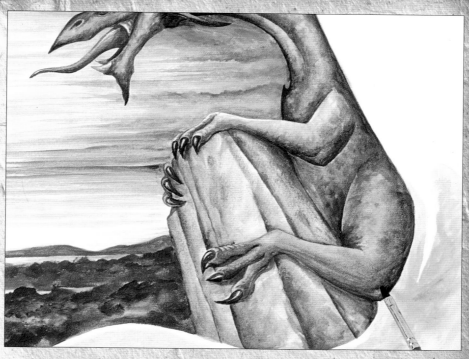

32 Paint the rear leg in the same way as the foreleg, following the instructions from steps 29 and 30 (see opposite).

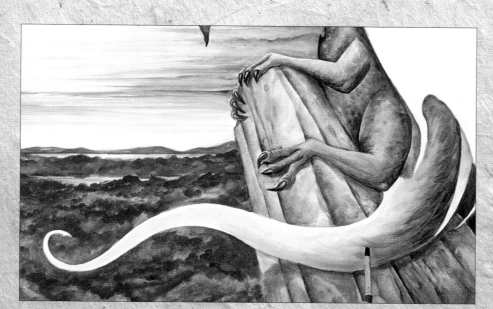

33 Paint the underside of the tail, starting from underneath the wing, using a strong mix of sap green and raw umber. Rather than shading with ivory black, introduce green umber to the mix and use strong brushstrokes with the 3mm (⅛in) flat bright for a textured appearance that suggests long spiralling scales.

34 Continue working along the tail, building it up with a slightly more dilute mix of sap green and raw umber, and using pure green umber to add some shading.

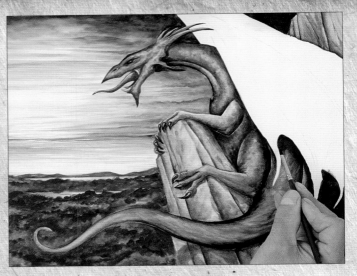

35 Work all the way along to the tip of the tail, building up the colour. Once dry, dampen the 3mm (⅛in) flat bright and rub the blade gently along the edge of the tail, lifting the colour out a little, ensuring that it remains bright and the colour remains strong at the very edge.

36 Strengthen the shadows across the body of the dragon with dilute ivory black and the 3mm (⅛in) flat bright.

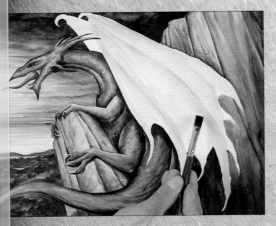

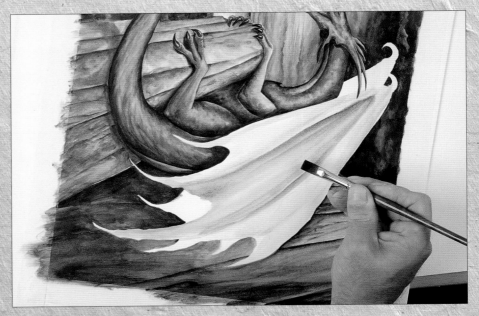

37 Switch to the 15mm (¾in) flat brush, wet the whole of the wings and lay in a faint wash of rich transparent red oxide, making it stronger over the supporting parts as shown.

38 Allow to dry, then turn the painting as shown. Lay a dilute wash of sap green and raw umber over the central part of the facing wing, starting from the bottom edges and drawing the paint across in clean strokes.

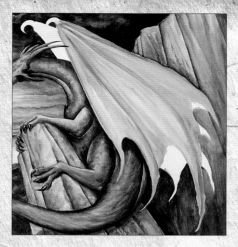 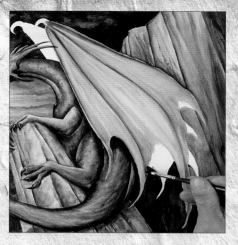

39 Paint the other sections of the facing wing in the same way. Use the blade of the brush to draw the wet paint in long lines, to suggest the structure and folds of the wing.

40 Develop some shading along the facing wing by drawing dilute green umber down the shaded parts beneath the thick supporting structures of the wing, using the 3mm (⅛in) flat bright.

41 Still using the same brush, reinforce the supporting struts of the wings with raw umber. Dry the 3mm (⅛in) flat bright and lift out highlights on the larger sections, then switch to the size 000 to develop the details.

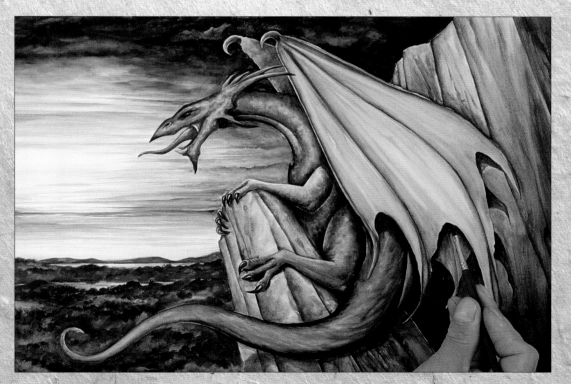

42 Mix green umber with raw umber for a darker tone of green. Use this shade to paint in the hidden wing, blending it away with a more dilute mix. Use the same dark tone for the claws on the tops of the wings, then allow the painting to dry completely. Carefully remove the masking tape to finish.

Overleaf
The finished picture.

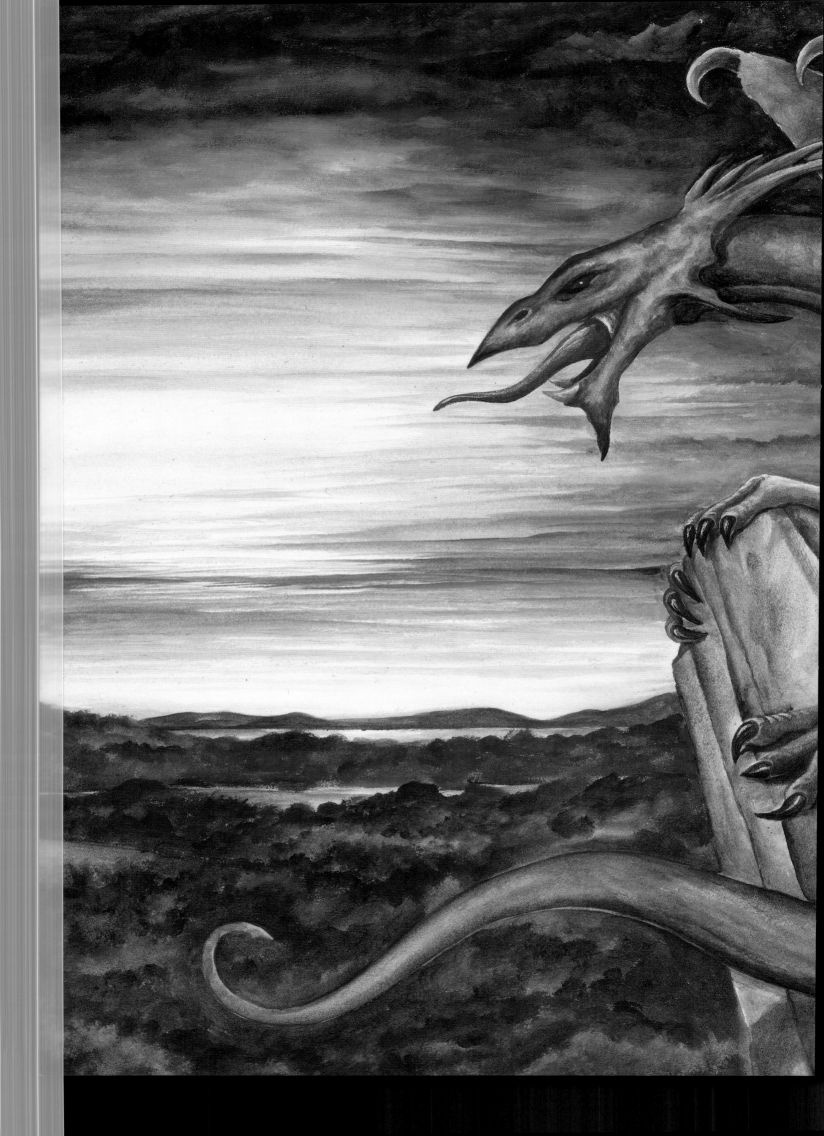

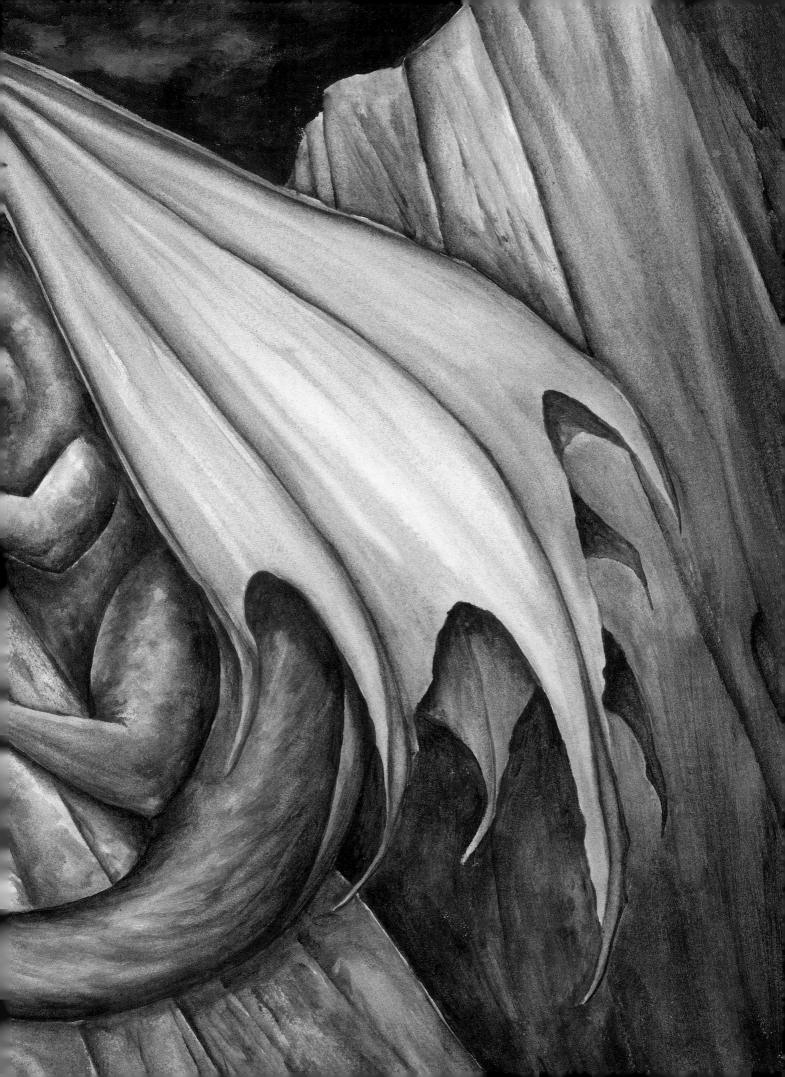

Salamander

*T*his picture is inspired by the notion of dragons being elemental beings of fire. Such elementals were sometimes termed 'salamanders' and so I have applied this to the title of the project. I have tried to further convey its fiery nature by painting the background as though the sky itself is on fire.

You will need

Watercolour board 60 x 76cm (23½ x 32in)

Colours: cadmium red deep, perinone orange, cadmium yellow deep, Van Dyke brown, ivory black

Brushes: 3mm (⅛in) flat bright, 10mm (⅜in) flat, size 000 round

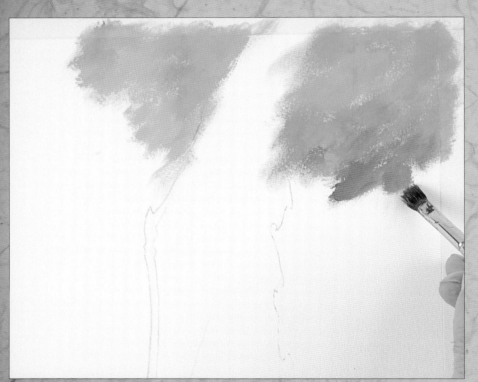

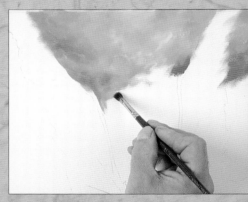

1 Transfer the image following the instructions on page 9, then run masking tape around the edges to create a border. Prepare your palette with the following colours: cadmium red deep, perinone orange, cadmium yellow deep and Van Dyke brown. Add a touch of perinone orange to cadmium yellow deep. Using the paint virtually undiluted with water, begin to paint in the upper right with short, stabbing strokes of the 10mm (⅜in) flat, avoiding the dragon's wing. Add more perinone orange as you come down the board.

2 Still using the 10mm (⅜in) flat, continue across the top of the painting in the same way, then start working down the centre. Introduce cadmium red deep to the mix as you pass the joint of the dragon's wing.

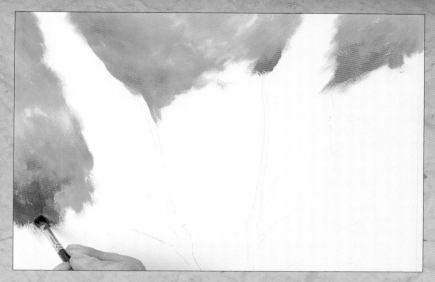

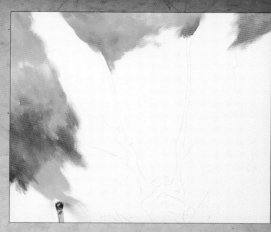

3 Work down the upper-left corner in the same way, aiming for a painterly, loose feel to the flame. As you work further down, add touches of Van Dyke brown on the left.

4 Continue working down the left-hand side, mixing and recombining the four colours. Try not to work in sections; overlap the areas of colour, blend the colours together on the board and aim for a loose and fairly free effect on your work.

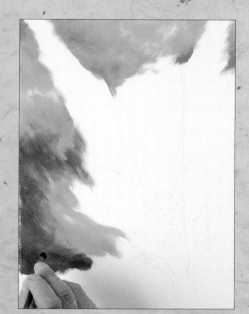

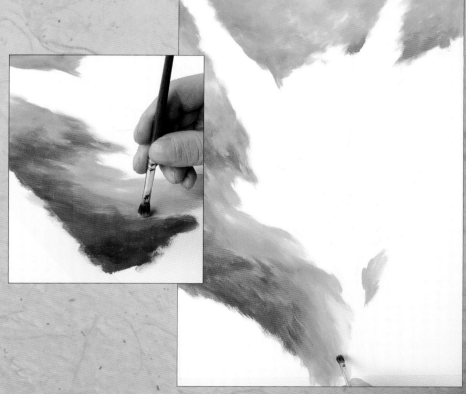

5 To really develop the depth of the fire, paint in darker areas using more cadmium red deep and Van Dyke brown, allow them to dry, and then draw nearly dry lighter colours back up the board. Ensure that the brush and underlayer is completely dry, or the paint will blend rather than give the correct effect.

6 Working the brushstrokes in diagonals up and away from the centre, and following the lines of the dragon's wings (see inset), paint down to the bottom of the page, keeping the yellows and oranges towards the centre and the darker browns and reds towards the edges.

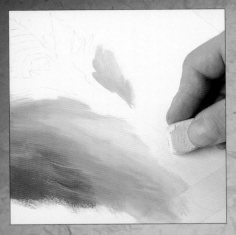

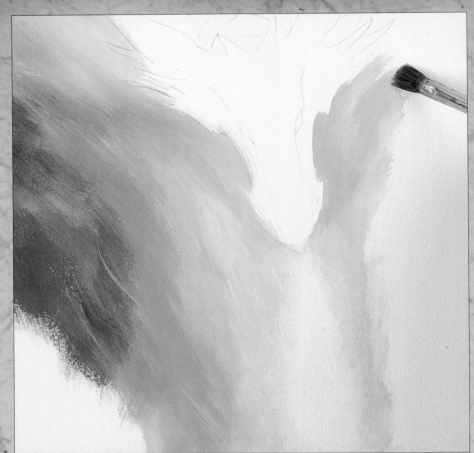

7 Use an eraser to rub away the tracing lines from the jet of flame. This will be left as clean board, so that it appears white hot.

8 Switch to the 10mm (⅜in) flat and work very light touches of purest cadmium yellow deep in towards the sides of the jet of flame, but leave the jet itself untouched. Start to work back up on the left, moving from pure cadmium yellow deep back into perinone orange.

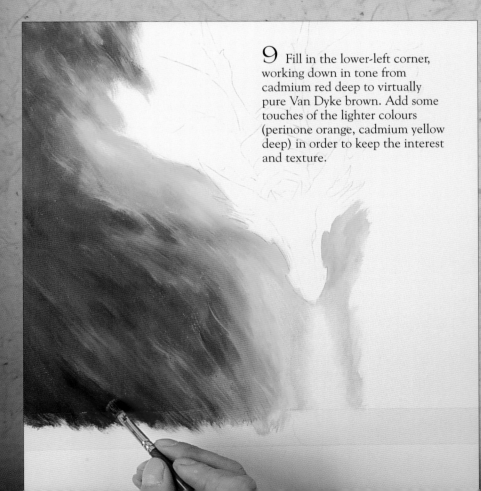

9 Fill in the lower-left corner, working down in tone from cadmium red deep to virtually pure Van Dyke brown. Add some touches of the lighter colours (perinone orange, cadmium yellow deep) in order to keep the interest and texture.

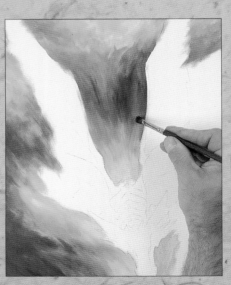

10 Paint in the area between the wings using almost vertical brushstrokes. Start with cadmium yellow deep near the dragon's back, then introduce perinone orange and cadmium red deep as you work into the colours above.

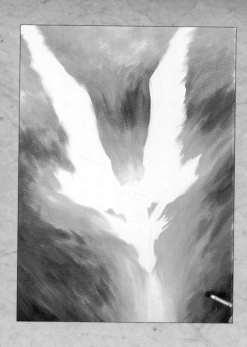

11 Work down the right-hand side in the same way as the left, varying, blending and overlaying the colours.

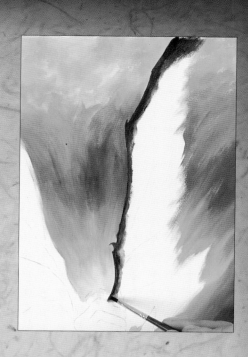

12 Swap to the size 3mm (⅛in) flat bright brush and use Van Dyke brown to line the inside edge of the wing on the right-hand side, swapping to the size 000 round for the spikes.

13 Starting with pure Van Dyke brown at the top, and introducing steadily more cadmium red deep towards the middle of the wing, use the 10mm (⅜in) flat to paint in the skin of the wings. Start from the dark leading edge and use broad, steady brushstrokes. Use the blade of the brush to emphasise the supporting parts of the wing with a less dilute mix of the same colours.

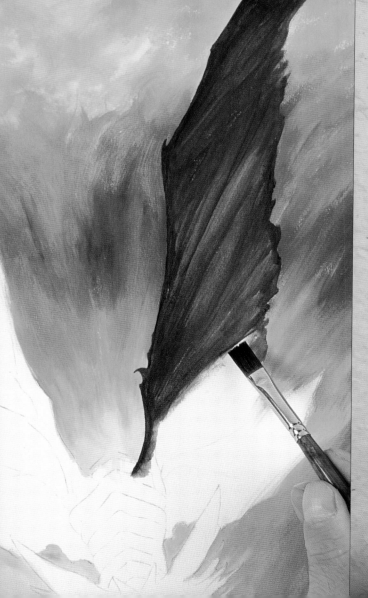

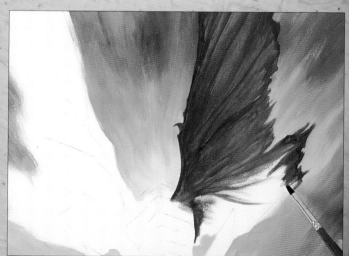

14 Continue down the wing, introducing more cadmium red deep, but saving Van Dyke brown for the trailing outside edge of the wing. As you reach the parts nearest the body, swap to the size 3mm (⅛in) flat bright.

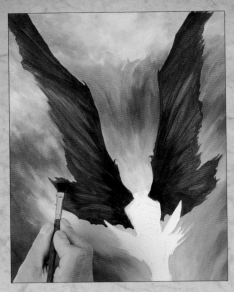

15 Complete the wing with very strong, dark tones of Van Dyke brown and cadmium red deep in the area nearest the head. Blend in more strokes of the same paints to keep the area vibrant.

16 Paint the wing on the left-hand side using the same paint mixes and techniques as the other wing.

17 Switch to the 3mm (⅛in) flat bright and use a mix of cadmium red deep and ivory black to lay in some darks on the dragon's neck, creating a stark contrast with the bright yellow background.

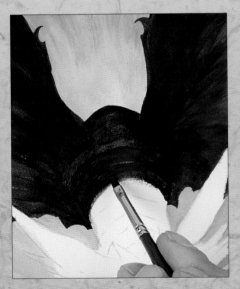

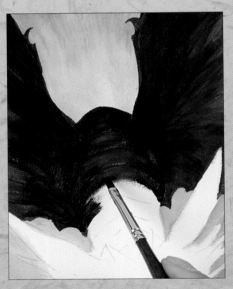

18 Using a slightly more dilute mix of the same colour, work along the neck, suggesting the ridges of the scales by using the edge of the brush to encourage the paint to gather on the lines of the tracing. Strengthen the colour at the edges of the neck more than the centre, as shown.

19 Strengthen the colours by using more black at the edges of the neck scales and more red in the centres. Blend the areas of colour in the individual scales together smoothly on the board.

20 Add some more pure cadmium red deep right in the centre of each scale, and only blend the edges of the area in, to leave a stark red highlight.

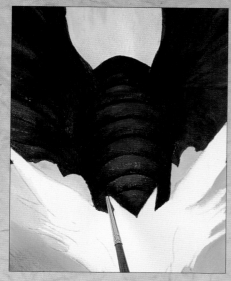

21 Paint the remaining scales on the neck in the same way, then use the size 000 round to line the gaps between the scales with pure ivory black. Strengthen the edges of the neck with ivory black, too.

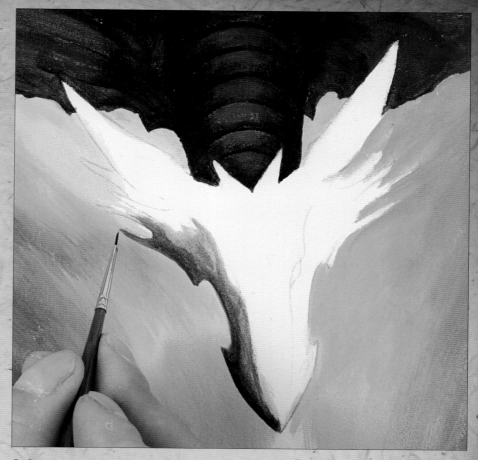

22 Switch back to the 3mm (⅛in) flat bright and begin to lay in a base colour on the dragon's head using a dilute mix of Van Dyke brown and cadmium red deep. Use the blade of the brush to ensure a crisp edge, or switch to the size 000 for particularly tricky details.

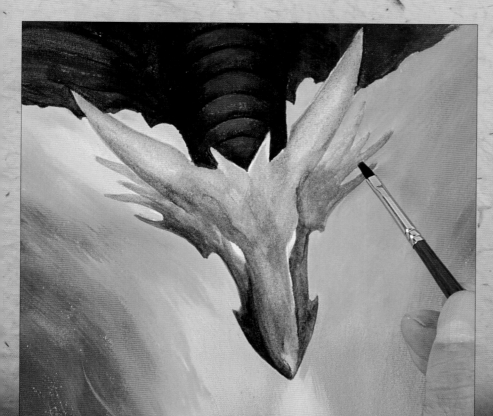

23 Fill in the rest of the head with the same mix. Keep the colour fairly pale in the centre, and darker at the edges. Leave gaps for the eyes as shown.

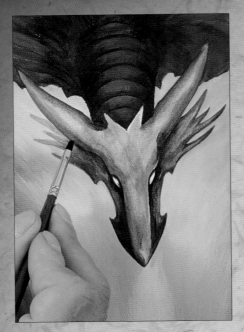

24 Make a black and red mix and use it to develop the modelling, laying in shadows on either side of the muzzle and the eyes. Use the size 000 to tidy up and edge the horns and the 3mm (⅛in) flat bright to develop the shading with dilute glazes.

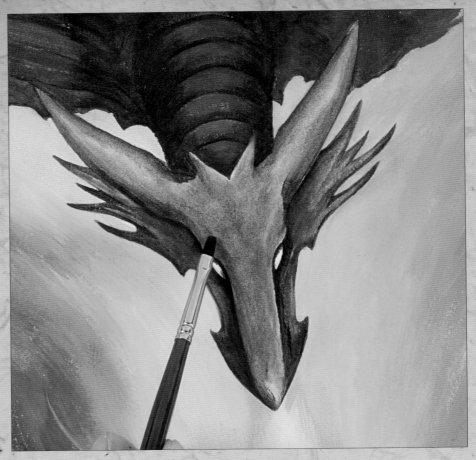

25 With the 3mm (⅛in) flat bright lay in a dilute wash of cadmium red deep over the centre of the dragon's head and down the muzzle.

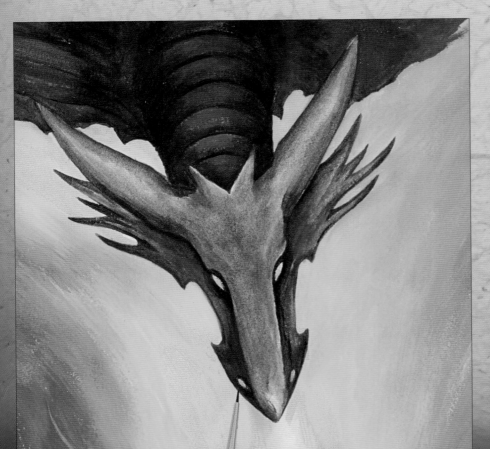

26 Use the size 000 round with cadmium yellow deep to paint in the eyes and nostrils. Allow the painting to dry completely, then carefully remove the masking tape to finish.

Opposite

The finished picture, reduced in size.

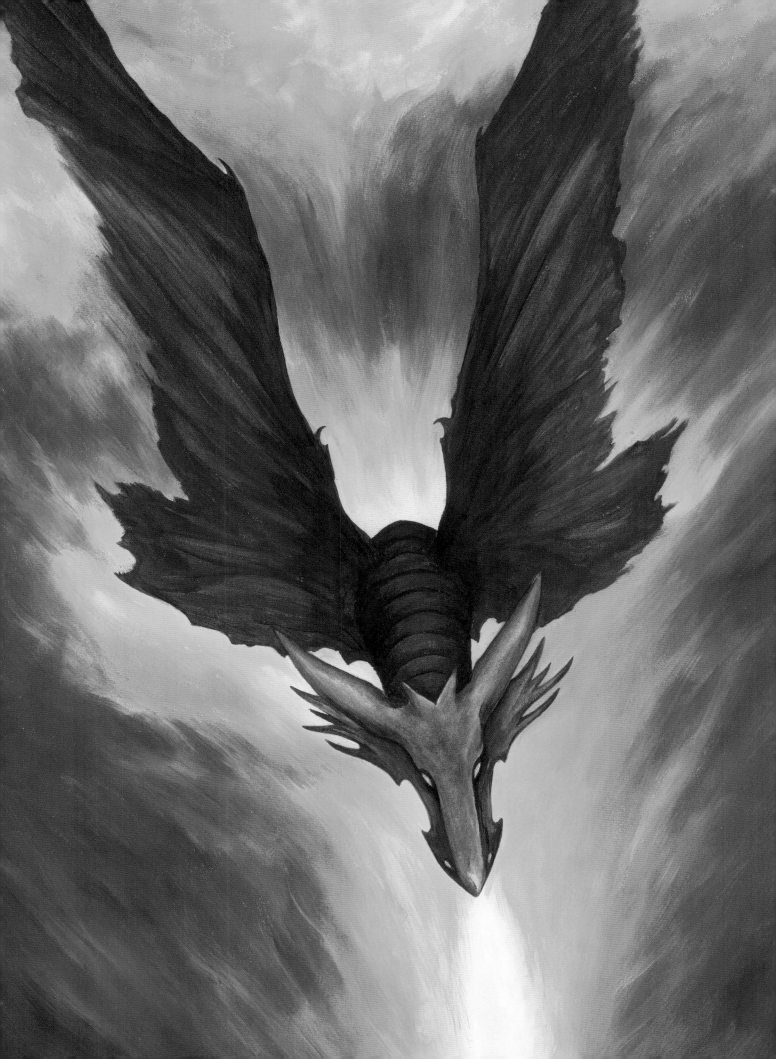

The Nursery

I had the idea that if dragons were magical beasts of fire, they might be born of it. In this painting young dragons are creatures emerging from the molten core of the Earth through volcanoes and sustained by the flow of lava.

TRACING

4

You will need

Watercolour board 76 x 60cm
(32 x 23½in)

Colours: perinone orange, raw umber, Van Dyke brown, ivory black, cadmium yellow deep, burnt umber

Brushes: 10mm (⅜in) flat, size 000 round, 3mm (⅛in) flat bright

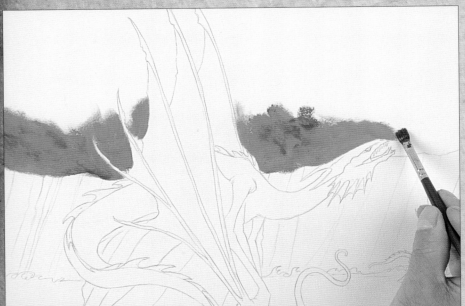

1 Transfer the image following the instructions on page 9, then run masking tape around the edges to create a border. Prepare your palette with the following colours: perinone orange, raw umber and Van Dyke brown. Using the 10mm (⅜in) flat, begin to lay in dilute perinone orange on the horizon. Add touches of raw umber in occasionally, mixing the paint together on the board in order to suggest a broiling, moody sky.

2 Continue to lay in the sky across the horizon using short, scrubby strokes of the brush. Swap to the size 000 round and use this with perinone orange to touch in the hard-to-reach details such as the inside of the dragon's mouth.

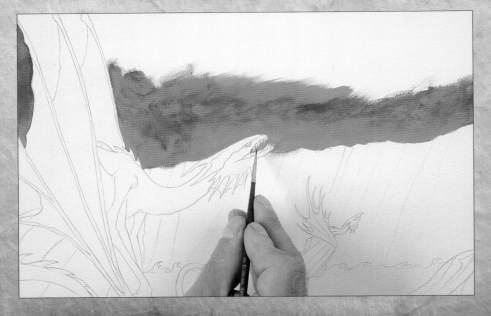

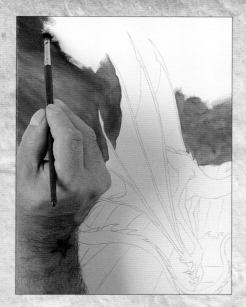 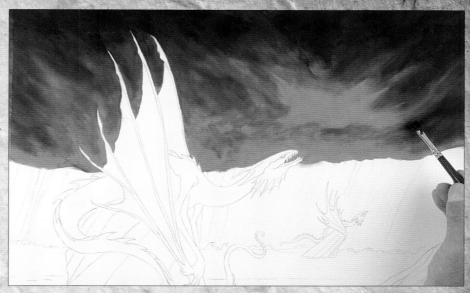

3 Continue working the sky up to the top of the painting using the 10mm (⅜in) flat brush and the same colours. Gradually add small amounts of Van Dyke brown to the mix until you are working with pure Van Dyke brown at the extreme top of the painting.

4 Paint the remainder of the sky in this way. The aim is to create a stormy sky with strokes and patches of different tones, so work a broken effect when blending the colours. Use buttery paint, with virtually no water added, and blend small areas of colour together lightly.

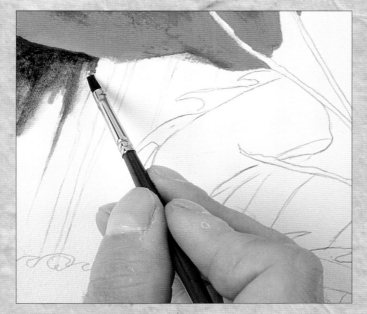

5 Make a buttery dark mix of raw umber and ivory black and use the 3mm (⅛in) to begin painting the volcano walls on the left. Draw the paint across a section of the lip of the volcano, then dampen the brush and draw the paint downwards to fade it out.

6 Use darker tones at the bottom of the rocks, too. This will create a strong contrast with the lava later. Use the blade of the brush to introduce darker, near-parallel, strokes, using the lines of the tracing as a guideline.

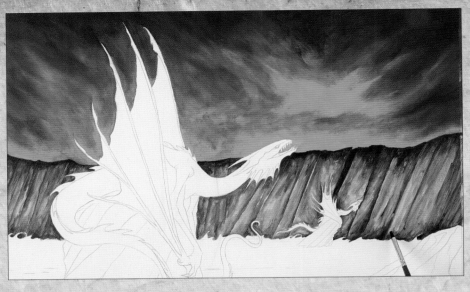

7 Continue filling in the rockface on the left up to the dragon, using the size 000 round to touch in the final parts around the dragon's spinal frill.

8 Starting on the other side of the dragon, paint in the volcano wall across the rest of the painting in the same way.

Tip

You may find it useful to start with the size 000 round to fill in the sections around the dragons as you begin.

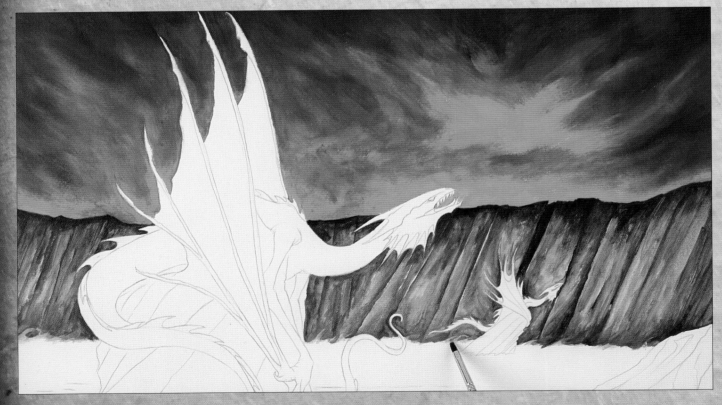

9 Add some hints of light from the lava at the bottom of the volcano wall using very light touches of perinone orange and cadmium yellow deep, applying the paint with short flicking motions of the 3mm (⅛in) flat bright.

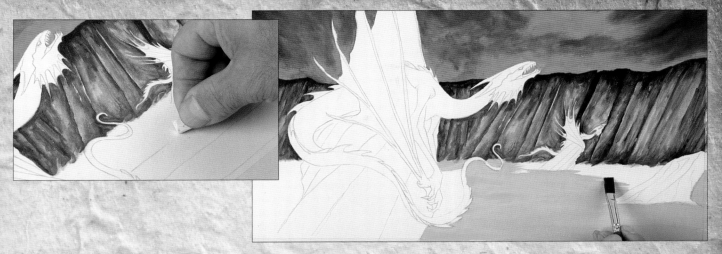

10 Use an eraser to soften the tracing lines on the lava pool (see inset), then use the 10mm (⅜in) flat to lay in a dilute wash of cadmium yellow deep over the lava field, working with narrow horizontal strokes from the bottom of the painting upwards.

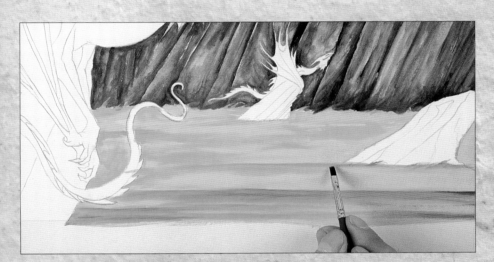

11 Once the yellow field is finished on both sides of the main rock, swap to a 3mm (⅛in) flat bright and add in some soft horizontal strokes of perinone orange. Again, start from the bottom of the painting.

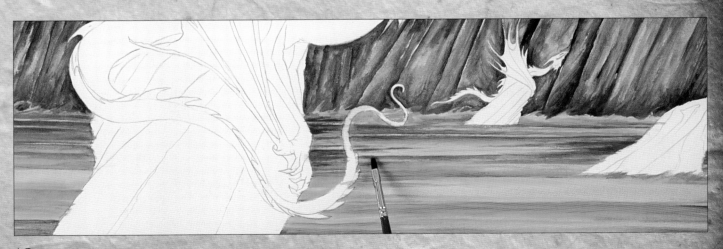

12 Still using the same brush, introduce Van Dyke brown and cadmium red deep into the horizontal strokes. Mix and recombine the colours for a varied effect. Leave some areas of pure yellow showing through.

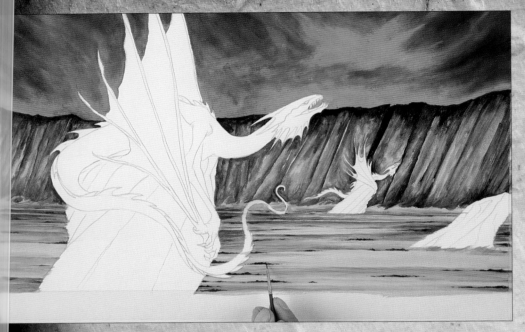

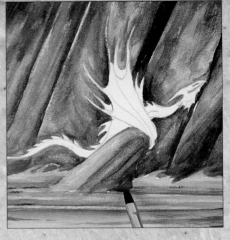

13 Use Van Dyke brown with the size 000 round to paint in some small areas of cooling molten rock. Keep them fairly small, and keep the bottoms of the shapes as level as you can. The tops can be a little more ragged, but be careful not to make the shapes too tall.

14 Paint the rock on which the rear dragon is perching, using raw umber and the 3mm (⅛in) flat bright. Use a dilute mix on the left, and strengthen it as you work to the right. Suggest furrows in the rock by adding darker stripes with stronger mixes. Use the lines on the tracing to suggest their direction, and the blade of the brush to paint them.

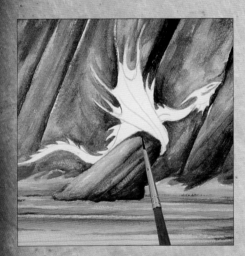

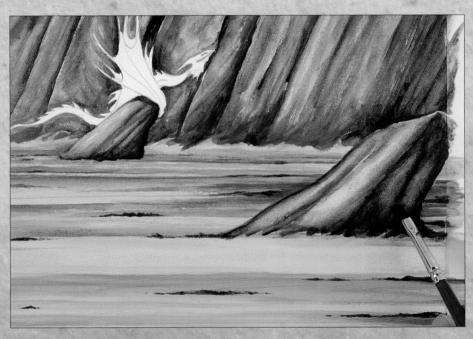

15 Switch to the size 000 round and touch in a light shadow on the bottom and right of the rock and also underneath the dragon.

16 Paint the rock on the right with the 3mm (⅛in) flat bright and raw umber, remembering to keep the right-hand side darker than the left-hand side. Since this rock is closer to the viewer, keep the furrows spaced further apart than in the distant one.

17 Using the 3mm (⅛in) flat bright, lay in a wash of raw umber on the main rock, starting from the left. Use the lines on the tracing as suggestions for the contours, laying in darker raw umber in these areas. If you need to lighten any areas for highlights, you can lift out the colour a little with a clean damp brush and a gentle scrubbing motion.

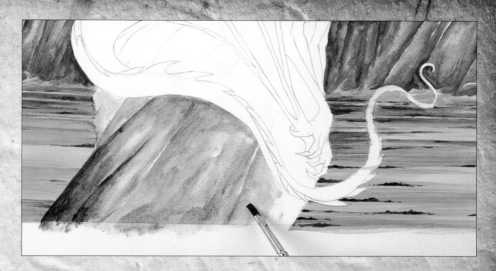

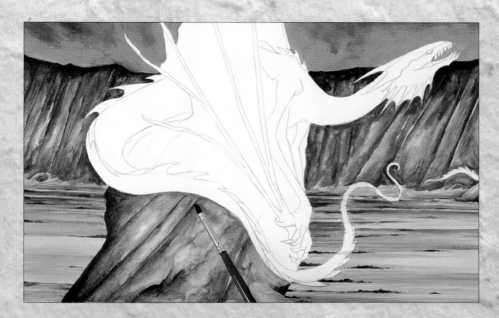

18 While the paint is still wet, develop the furrows and shadows with dilute Van Dyke brown, using the blade of the brush for finer lines. Again, lift out highlights with a clean damp brush, or by moving the paint aside while it is still wet.

19 Use a wash of Van Dyke brown to lay in the shadow of the dragon's tail (see inset), then paint the upper part of the rock in the same way as the bottom. Include the shadow of the dragon's body, then switch to the size 000 round to touch in any tiny details, such as the areas between the dragon's claws.

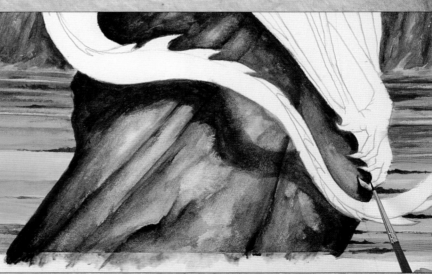

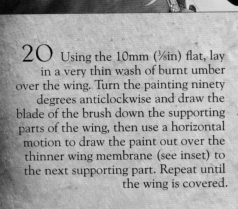

20 Using the 10mm (⅜in) flat, lay in a very thin wash of burnt umber over the wing. Turn the painting ninety degrees anticlockwise and draw the blade of the brush down the supporting parts of the wing, then use a horizontal motion to draw the paint out over the thinner wing membrane (see inset) to the next supporting part. Repeat until the wing is covered.

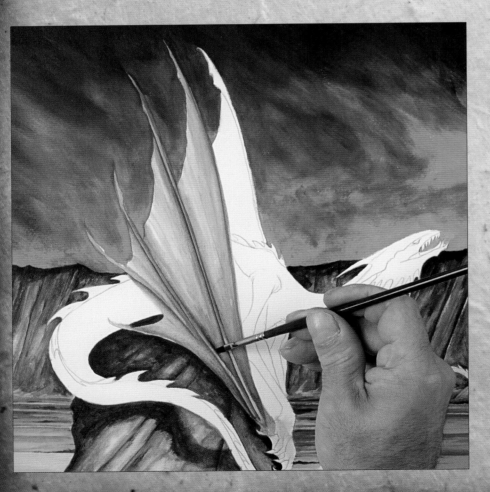

21 Switch to the 3mm (⅛in) flat brush and apply glazes of burnt umber on to the wing in order to develop the structure and shading.

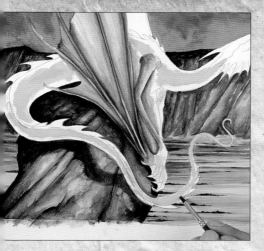
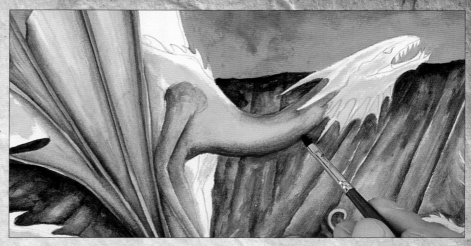

22 Develop colour and shading on the arm of the wing in the same way, then apply some dilute cadmium yellow deep over the centre of the body of the dragon.

23 Work the yellow over the head and arm, then make a mix of burnt umber and perinone orange and apply it at the top and bottom of the neck, working it in around the horns and frill of the dragon. Blend it in to the yellow on the neck and use the blade of the brush to strengthen the colour at the bottom.

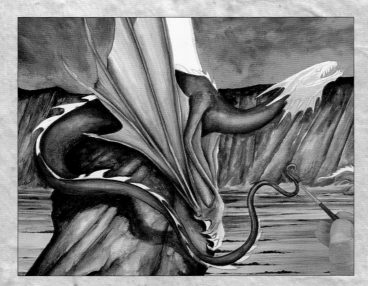
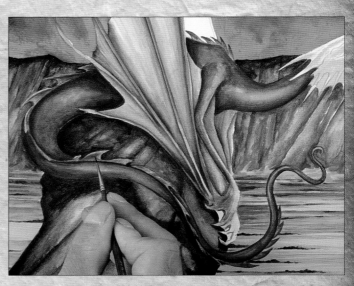

24 Continue shading in this way over the rest of the body, switching to Van Dyke brown for the extreme recesses, and using the size 000 round for the narrower parts, such as the tip of the tail.

25 Paint the spinal fin with the size 000 round and perinone orange. Glaze some burnt umber in the recesses and areas in shadow.

26 Using the size 000 round, paint in the dragon's claws using fairly thick ivory black, then switch to burnt umber and develop the structure of the forepaws. Add some fine lines across the 'fingers' for a bird-like effect.

27 Shade the rear wing arm with Van Dyke brown, then paint the rear wing using the same techniques as in steps 20–21. Use slightly stronger mixes of burnt umber in order to create the shaded effect on the wing.

28 Use dilute Van Dyke brown to paint in a band of shadow under the head crest. Blend it away fairly sharply with the size 000 round.

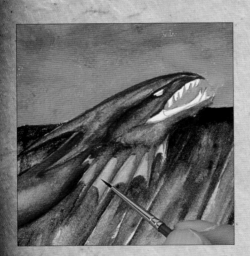

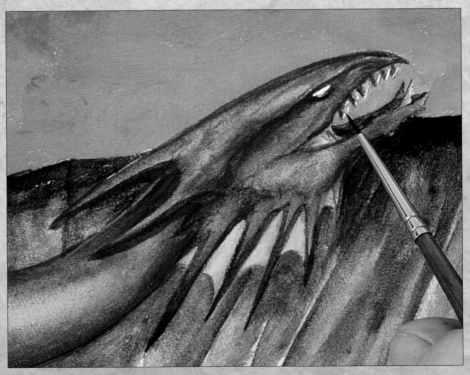

29 Switch to burnt umber to lay in shading and modelling at the edges of the head as shown. Use the 3mm (⅛in) flat bright for the larger areas, lifting out excess paint if necessary, but switch to the size 000 round for the smaller details.

30 Still using the size 000 round, edge the spines of the dragon's frill with burnt umber, then paint the inside of the mouth with the same colour. Touch in the base of each tooth with dilute raw umber to create shading, but leave the majority of each tooth the white of the clean board.

31 Paint in the eye with perinone orange and the tip of the size 000 round.

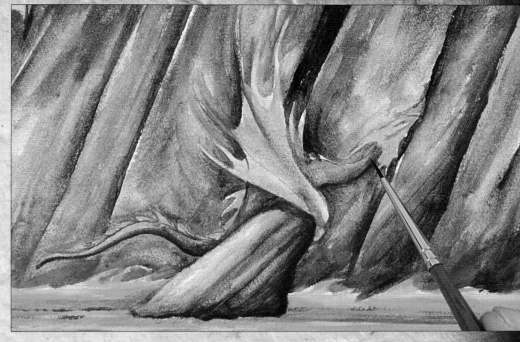

32 Using slightly more dilute mixes of the colours used on the foreground dragon (cadmium yellow deep, then burnt umber and perinone orange for the body, and burnt umber for the wing), lay in the block colours for the background dragon using the 3mm (⅛in) flat bright and size 000 round for tight details.

33 Paint in the details on the background dragon using the size 000 round and Van Dyke brown. Allow the painting to dry completely, then carefully remove the masking tape to finish.

Overleaf

The finished picture.

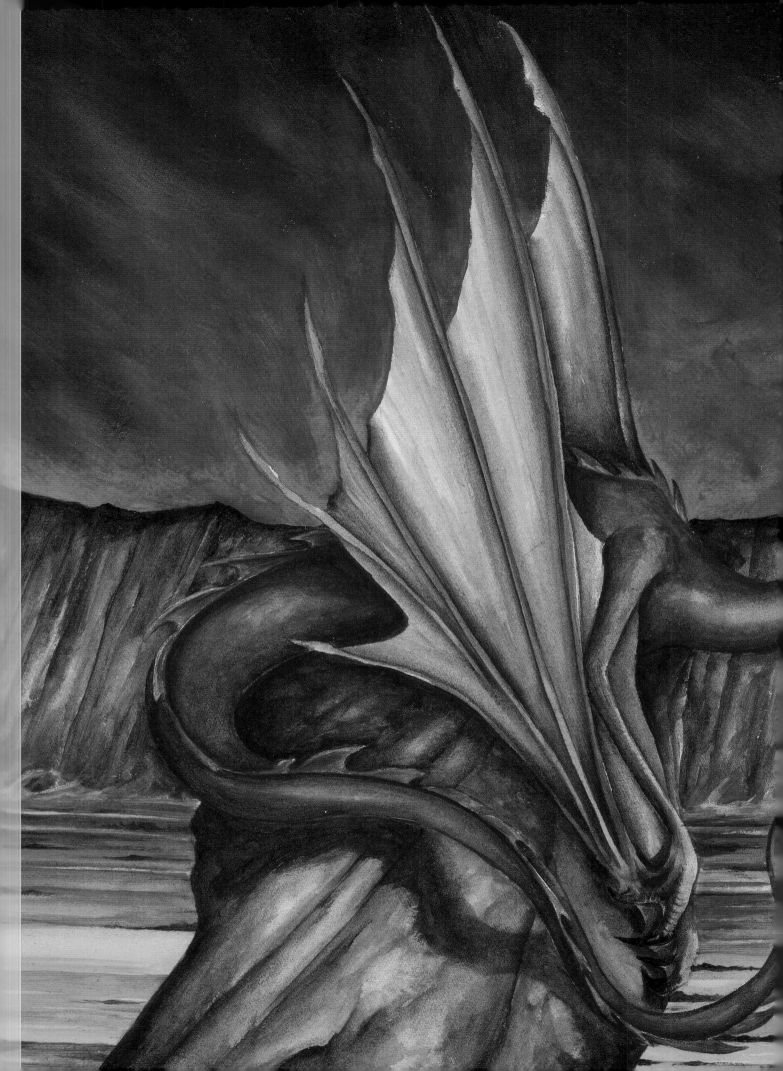

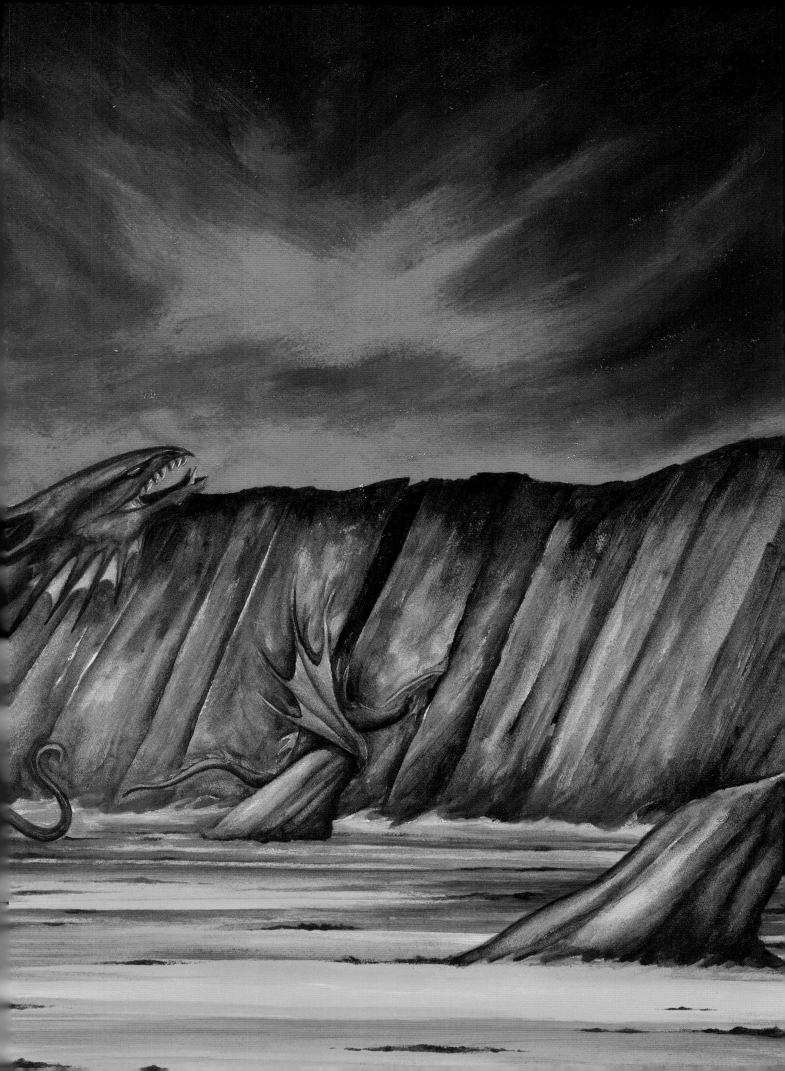

Firestorm

*T*he vengeful dragon awakened, burning the castle and town of those that roused it... Or perhaps it was simply not placated with a supply of the virgins from the kingdom?

This is an iconic image of a dragon, and one used in a number of famous fantasy stories.

You will need

Watercolour board 76 x 60cm (32 x 22in)

Colours: burnt umber, rich transparent red oxide, Van Dyke brown, ultramarine blue, cadmium yellow deep, perinone orange, cadmium red deep, ivory black, titanium white

Brushes: 3mm (⅛in) flat bright, size 000 round, 10mm (⅜in) flat

1 Transfer the image following the instructions on page 9, then run masking tape around the edges to create a border. Prepare your palette with the following colours: burnt umber, rich transparent red oxide and Van Dyke Brown. Use a 3mm (⅛in) flat to lay in burnt umber on the outlines of the dragon's head, then rinse your brush, remove excess water and use the damp brush to soften it in towards the centre.

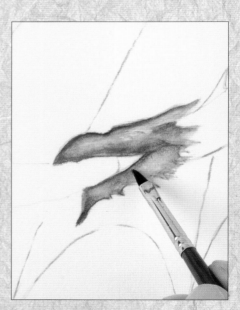

2 Warm the dragon's open mouth with a glaze of dilute rich transparent red oxide.

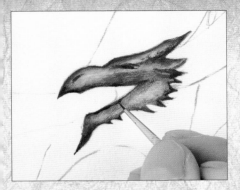

3 Switch to the size 000 round and strengthen the shadows on the dragon's head using Van Dyke brown, softening the colour away with a clean damp brush, as before. Make the tips of the horns the darkest of all, as this helps them to stand out. Use the same colour to paint in the eye and nostril.

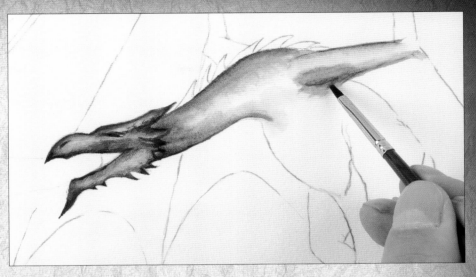

4 Using burnt umber and the 3mm (⅛in) flat bright, begin to outline the dragon's neck and foreleg. While the paint is wet, soften it in towards the centre of the dragon with a clean damp brush. Make the part of the neck immediately behind the head the darkest area.

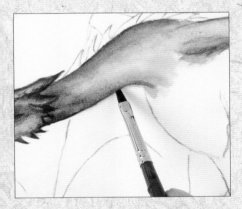

5 Add a very faint hint of rich transparent red oxide to the inside of the dragon's neck, to suggest the glow from the fiery breath.

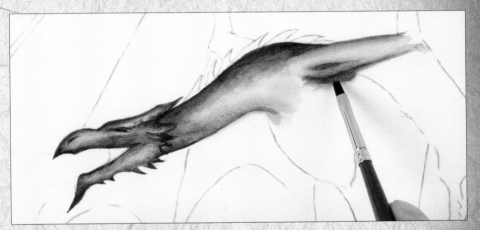

6 Switch to Van Dyke brown and fill in the deep shadows of the dragon's musculature as shown, softening the colour into the others.

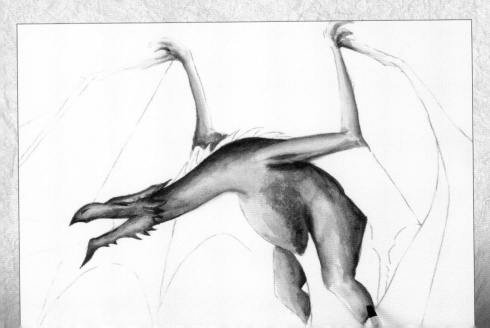

7 Paint the outline of the dragon's body with burnt umber and soften it inwards. Try and keep the highlights towards the jet of flame from the dragon's mouth, and the darker tones on the opposite side. Continue filling in the dragon's body, then paint the remaining legs, paying careful attention to the direction of the light source from the flame.

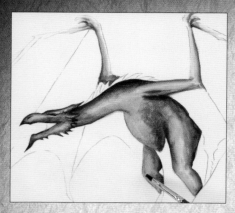

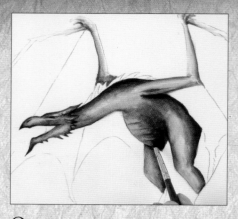

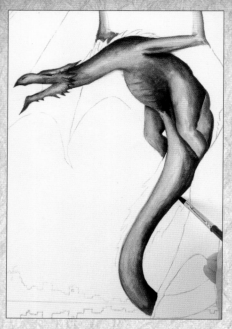

8 Still using the 3mm (⅛in) flat bright, lay in faint glazes of rich transparent red oxide on the sides of the lower limbs and body that face the flame, to suggest light reflected on to them from the jet of fire.

9 Suggest the darkest tones on the dragon's body and limbs with Van Dyke brown, then use the blade of the brush to suggest the shape of the largest scales on the dragon's front.

10 Paint the dragon's tail using the same brushes, colours and techniques up until it is hidden behind the wing. Use the blade of the brush to get the sharp edge.

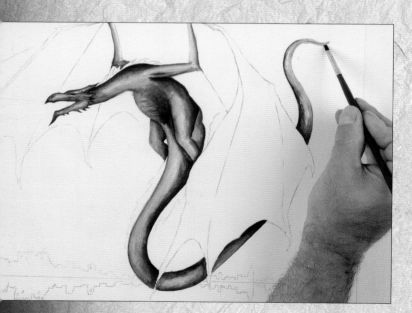

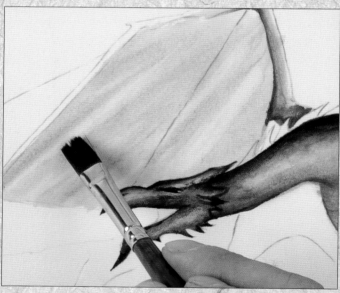

11 Paint the rest of the dragon's tail, making it progressively darker as the distance between the tail and the flame increases, and lighter at the tip, where the highlights are strongest. Do not add the glaze of rich transparent red oxide to these parts of the dragon, as they are too far away to reflect the flame.

12 Switch to the 10mm (⅜in) flat and wet the inside of the far wing. Make a very watery mix of rich transparent red oxide and burnt umber and lay it in fairly loosely over the wing. While the paint is still wet, clean and dry your brush and use the blade of it to lift out highlights on the wing to suggest texture.

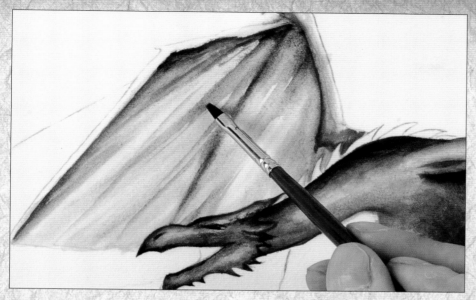

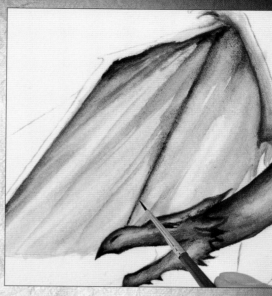

13 Allow the paint to dry, and then draw burnt umber down the supporting parts of the wing with the 3mm (⅛in) flat bright. Use the same colour and brush to introduce some shading. Allow the paint to dry completely on the wing before continuing.

14 Switch to the size 000 round and run a fine line of Van Dyke brown down the wing to shade the supporting parts.

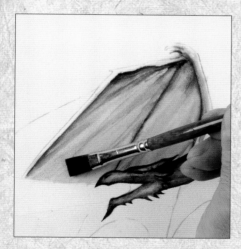

15 Switch back to the 10mm (⅜in) flat and use it to wash dilute rich transparent red oxide over the inside of the wing section.

Tip

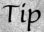

You do not need to be too neat when painting the inside of the wings, as the sky will cover the outside edges. However, be careful not to overlap the jet of flame, as this must remain clean.

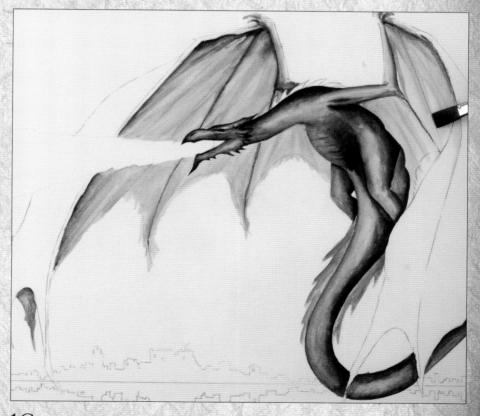

16 Wash the other inside parts of the wing with the same colour and the 10mm (⅜in) flat, then switch to the 3mm (⅛in) flat bright to paint the frill on the first part of the tail, again using transparent red oxide. Once dry, lay in fine lines of Van Dyke brown down the supporting parts with the blade of the 10mm (⅜in) flat.

45

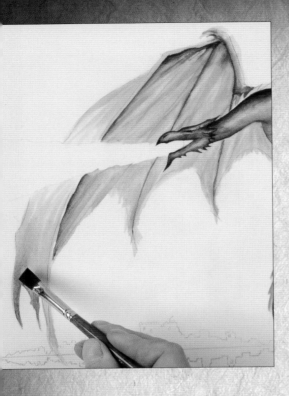

17 Using the 10mm (⅜in) flat, lay in a dilute wash of burnt umber on the outside of the wing on the left-hand side of the picture. Overlay the supporting parts of the wing with a slightly stronger mix and allow to dry.

18 Lay in a dilute burnt umber wash over the wing on the right-hand side in the same way.

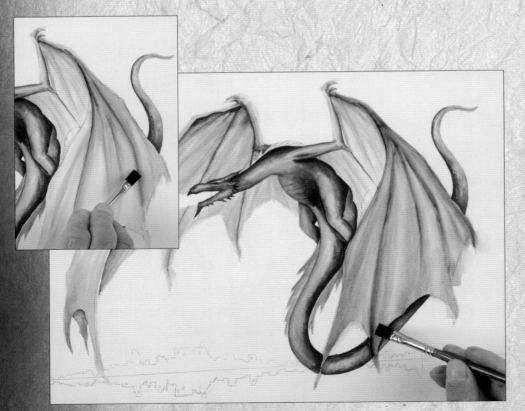

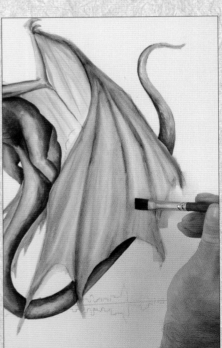

19 Starting from the top of the right-hand wing, draw dilute ultramarine down the supporting structures using the corner point of the 10mm (⅜in) flat brush (see inset). Rinse your brush, shake off excess water, then use the damp brush to gently blend the blue over the rest of the wing.

20 Quickly clean and dry the 10mm (⅜in) brush and use it to lift out highlights in the central parts of the wing membranes.

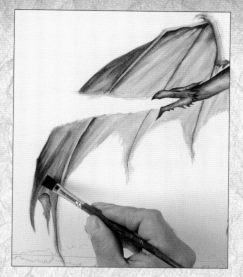

21 Wash the left-hand wing with dilute ultramarine blue, then add a touch of burnt umber to the mix and shade the wing at the top and bottom as shown.

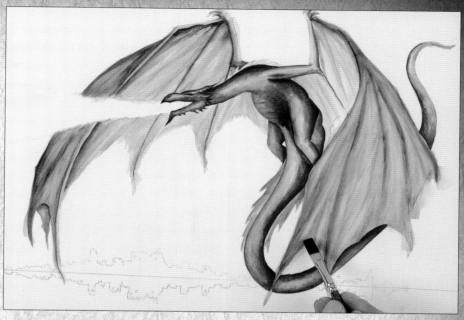

22 Once the right-hand wing is completely dry, add a glaze of rich transparent red oxide.

23 Paint the ridge of spines, using the size 000 round. Use Van Dyke brown for the spines in front of the wing, but use very dilute burnt umber for the ones silhouetted against the sky. While these are wet, work Van Dyke brown into the bases only, leaving the tips light.

24 Add some deep shading on the supporting parts of the wings using the size 000 round and Van Dyke brown.

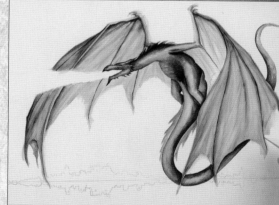

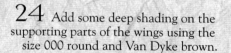

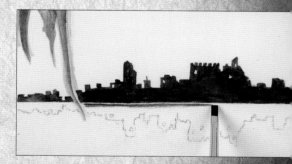

25 Outline the skyline on the horizon with Van Dyke brown and the size 000 round, then switch to the 3mm (⅛in) flat bright and use it to fill in the area. Leave a few gaps for windows and aim for a slightly patchy effect, which will enhance the flames added later.

26 Use the blade of the brush to paint in a very fine line of Van Dyke brown below the waterline. Leave an extremely fine line of clean board on the horizon itself.

47

27 Fill in the reflection of the town using slightly diluted Van Dyke brown. Use very short horizontal strokes when painting the reflection. This will result in the effect of slight ripples.

28 Still using the 3mm (⅛in) flat bright, begin to paint in the hottest parts of the blaze in the town. Use cadmium yellow deep and perinone orange, applying short strokes of the pure paints to the picture and blending them on the board, rather than on your palette. Work the strokes diagonally towards the top right.

29 Above the hottest part of the flames, paint in the cooler, redder parts. Work in the same way, but use perinone orange and cadmium red deep. Aim for a broken, overlaid feel so that you do not obscure the hotter parts. Use almost dry paint to pick up the texture of the surface of the board.

30 Paint in a few strokes of loose flame in front of the buildings with cadmium yellow deep, and paint the waterline on the horizon with the same colour.

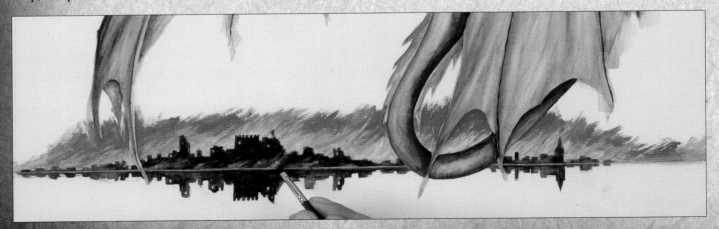

31 Paint the cloud of firelit smoke above the fire, starting with the area on the left. Work cadmium red deep and Van Dyke brown together on the surface of the board, still working broadly up to the top left.

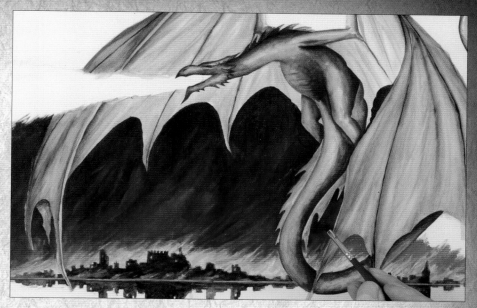

32 Continue painting the cloud of smoke across the painting, beneath the dragon's wings. Switch to the size 000 round when you are working very close to the edge of the dragon itself, so that you end up with a clean line.

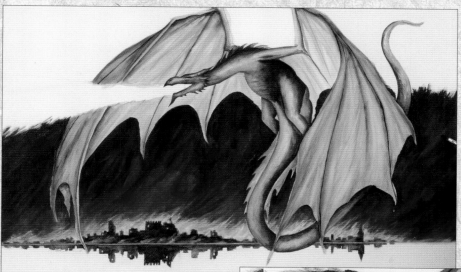

33 Work the smoke cloud up on the far right of the painting in the same way. Make the extreme lower corners darker than the rest of the cloud.

34 Switch to the 10mm (⅜in) flat and develop the smoke cloud around the dragon on the right and above the jet of flame.

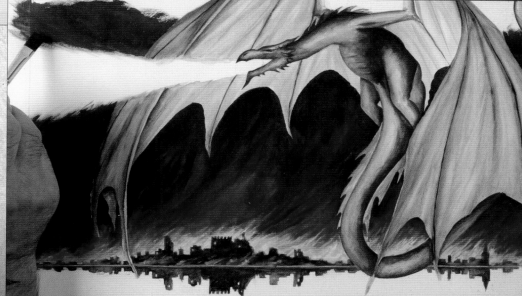

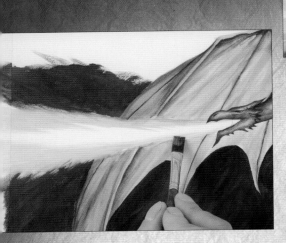

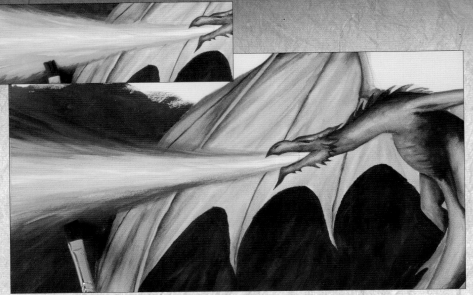

35 Leaving a core of clean board at the centre of the jet of flame, paint in cadmium yellow deep using the 10mm (⅜in) brush, keeping the brushstrokes short, light, and directed away and outwards from the dragon's mouth.

36 Build up the flame with more cadmium yellow deep and perinone orange at the edges, but keep the core clean (see inset). Repeat the process with cadmium red deep and a few touches of Van Dyke brown at the edges.

37 Switch to the 3mm (⅛in) flat bright and add in looser, more rounded strokes of the inner colours (cadmium yellow deep, perinone orange) streaming at the sides of the jet of flame. To finish the area, add a touch of dilute burnt umber to paint the inside of the dragon's mouth.

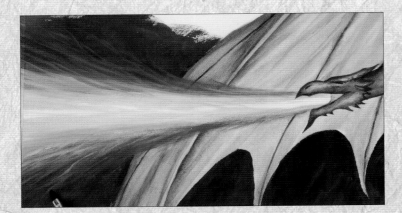

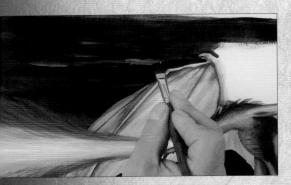

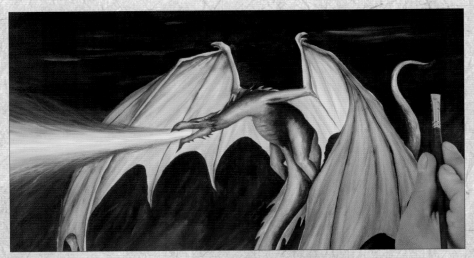

38 Still using the 10mm (⅜in) flat, lay in a basecoat of ultramarine and ivory black over the top of the sky, working long horizontal strokes. While the paint is wet, drop in subtle touches of titanium white and blend them horizontally with the blade of the brush, to suggest low-lying clouds.

39 Continue painting over the rest of the sky in the same way, swapping to the 3mm (⅛in) flat bright for hard-to-reach areas around the dragon and using diagonal brushstrokes to blend the sky into the cloud of smoke on the far right.

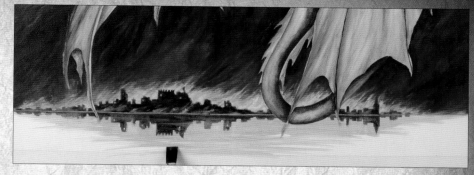

40 Add some final streamers of flame to the jet of fire, using the corner of the 10mm (⅜in) flat.

41 Use the blade of the 10mm (⅜in) flat to draw narrow horizontal strokes of cadmium yellow deep over the water at the bottom, concentrating them in the middle, working straight over the reflection of the town.

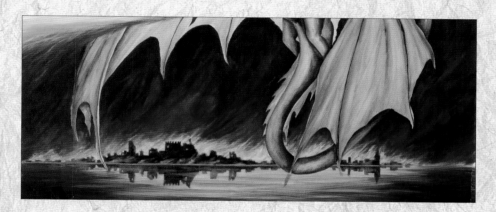

42 Repeat the process with perinone orange and cadmium red deep, gradually working away from the centre. Add in horizontal strokes of Van Dyke brown, varied with touches of cadmium red deep to finish the water. Remember, keep the strokes horizontal to represent reflections on the rippling water.

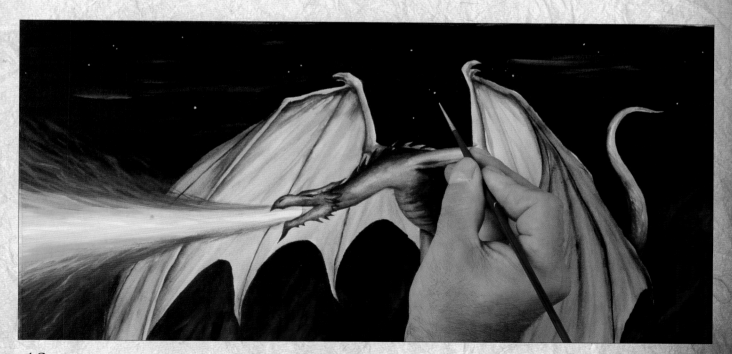

43 Touch in a few scattered stars in the darkest, topmost area of the sky using the tip of the size 000 round and pure titanium white. Allow the paint to dry, then carefully remove the masking tape to finish.

Overleaf
The finished picture.

51

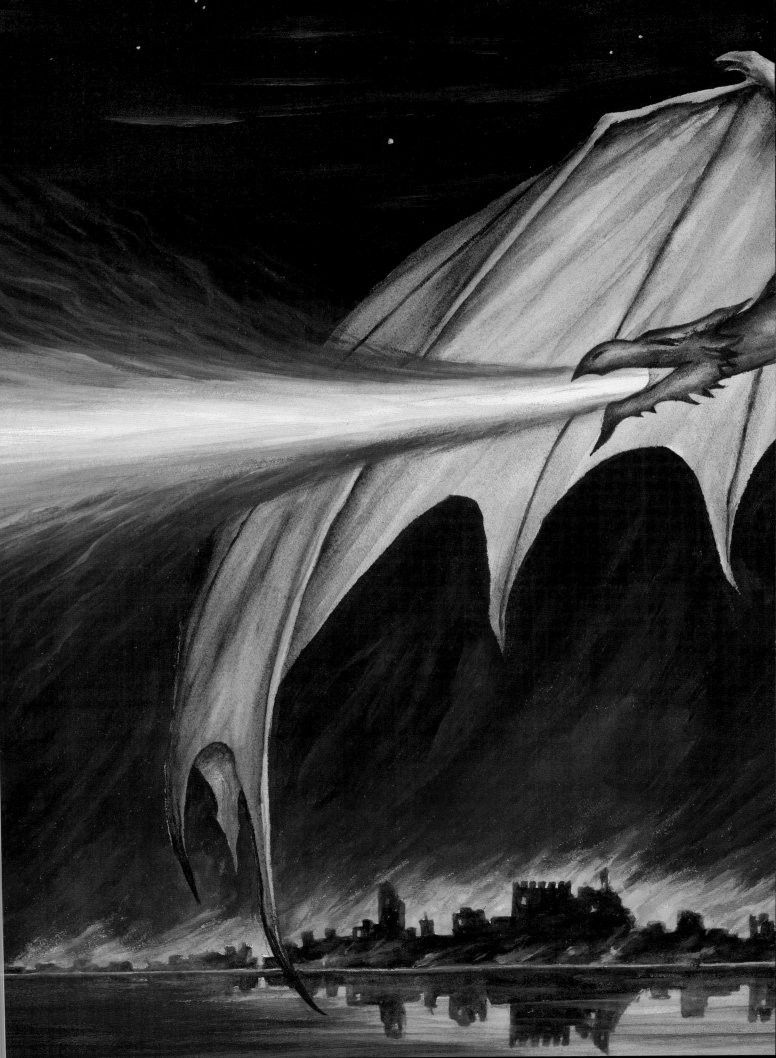

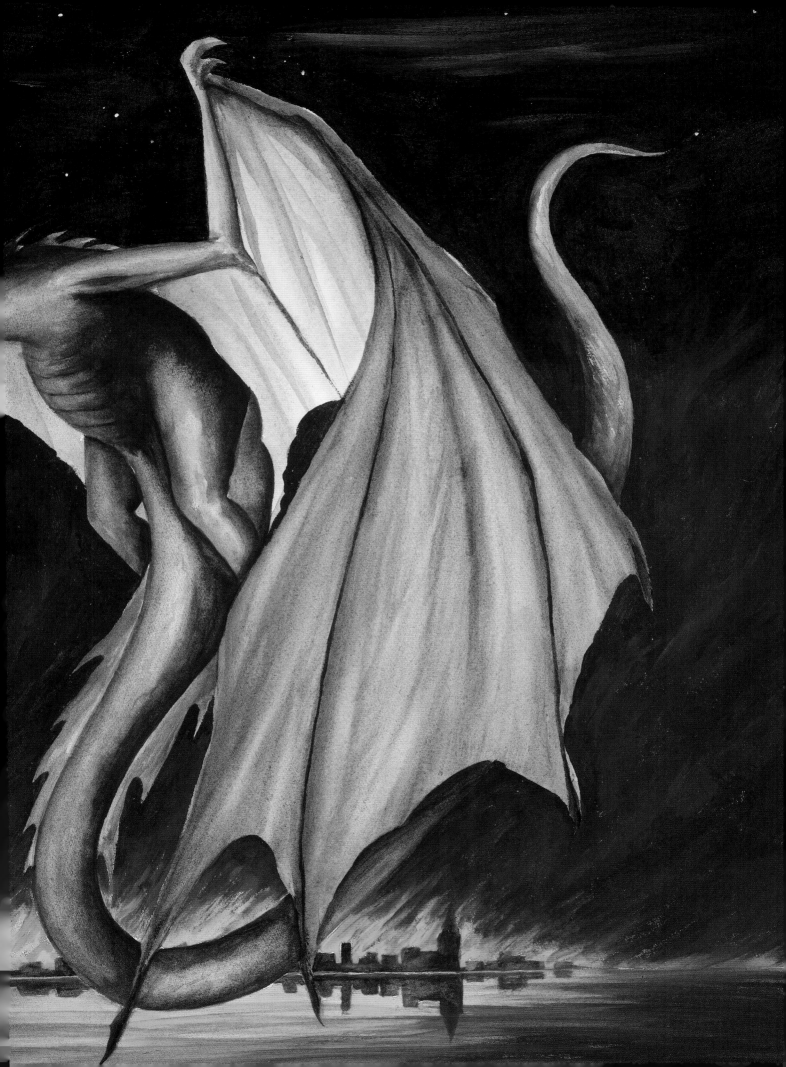

Glacier

There are legends of dragons from the coldest regions of the Earth as well. In this painting I wanted to show a huge ice dragon, ancient and powerful, surveying its kingdom.

TRACING

6

You will need

Watercolour board 60 x 76cm (23½ x 32in)

Colours: Prussian blue, titanium white, Payne's grey, deep violet

Brushes: 3mm (⅛in) flat bright, size 000 round, 15mm (¾in) flat

1 Transfer the image following the instructions on page 9, then run masking tape around the edges to create a border. Prepare your palette with the following colours: Prussian blue and titanium white and Payne's grey. Use the blade of the 3mm (⅛in) flat to draw Payne's grey down the furrows in the central background. Feather the paint downwards, following the lines of the tracing, and introduce some titanium white to vary the tone.

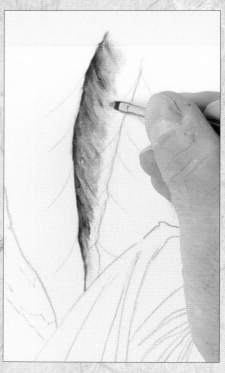

2 While the grey is still wet, work sweeping strokes of titanium white into the furrows, blending the paint together.

54

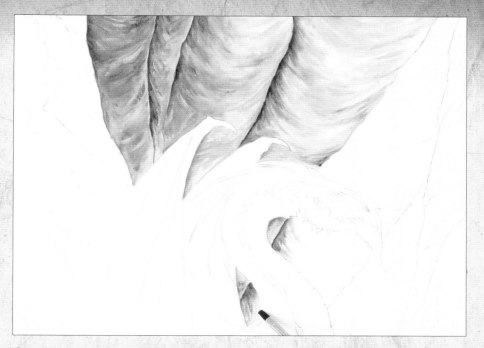

3 Work the other furrows around the dragon in the same way, blending the colour in loosely, and leaving the darkest tones in the deepest recesses. Follow the lines of the tracing to guide your brushstrokes when blending, and work very carefully in the areas bordered by the dragon's neck.

4 Complete the background glacier with the same colours and techniques.

5 Still using the same brush, begin to paint in the rock showing through the snow on the top left with neat Payne's grey. Use the blade of the brush in order to ensure crisp edges.

6 Work down the area on the left, filling in the larger areas of rock. Vary the tone and texture by diluting the Payne's grey, adding a touch of water to paint the slightly lighter areas.

7 Add a touch of Prussian blue to titanium white and dilute it to a watery mix. Apply this to the bottom of the areas of piled-up snow to create some very subtle shading.

Tip

To work awkward or out-of-the-way areas without putting your hands on the rest of the painting, simply turn the painting around.

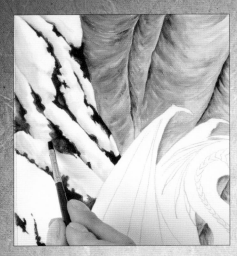

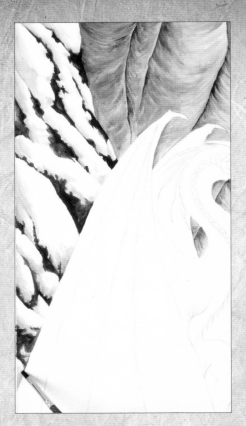

8 Continue to shade the snow on the top left-hand side of the painting in the same way. Add in subtle hints of diluted deep violet to add interest and variation.

9 Work down to the bottom of the left-hand area, adding the remaining shaded areas of the snow.

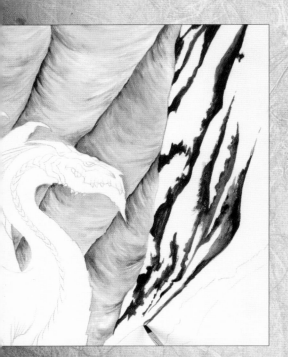

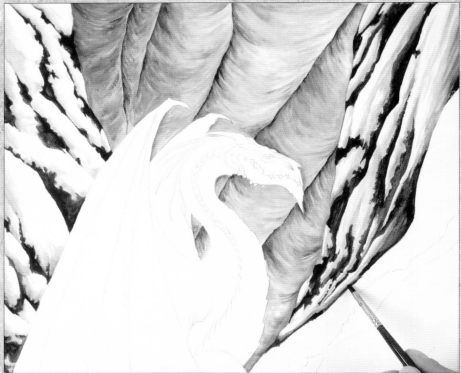

10 Paint the shaded recesses of the rock on the right-hand side in the same way, using diluted Payne's grey for lighter areas and stronger mixes for the recesses.

11 Shade the snow using diluted Prussian blue. Since this side is further in shadow than the left, add more diluted deep violet and hints of Payne's grey for the deepest shadows. Use longer brushstrokes and follow the lines of the tracing.

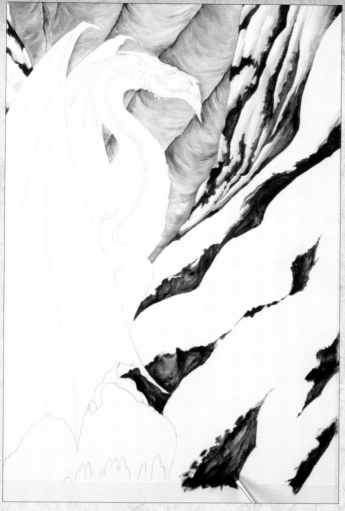

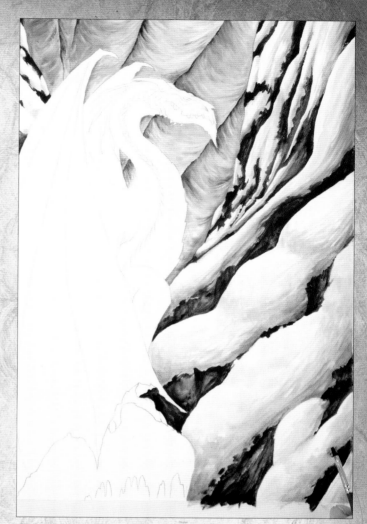

12 Work the larger areas of shadow in the foreground with dilute Payne's grey. Use larger, bolder strokes, as this area is closer to the eye.

13 Shade the snowy areas with flurries of short strokes.

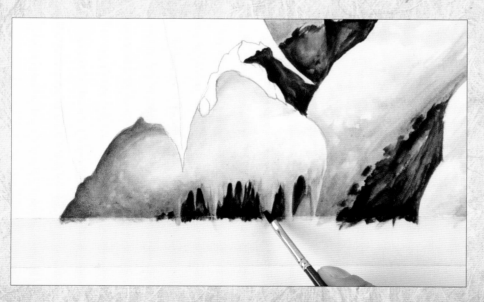

14 Still using the 3mm (⅛in) flat, fill in the dark area beneath the crag on which the dragon is perching. Use strong Payne's grey to get a rich, dark colour for this area. Paint the snow on top of the crag with dilute deep violet and Prussian blue, leaving the area on the right as clean board and adding the deepest shades beneath the dragon's wing. Use stronger Prussian blue on the icicles.

57

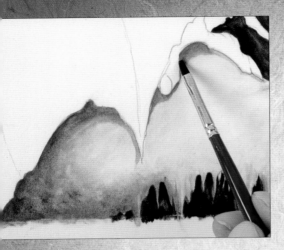

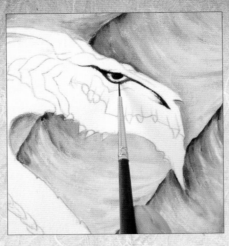

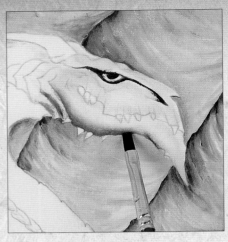

15 Darken the shadow colours with Payne's grey and paint in the direct shadow of the dragon's wing.

16 Switch to the size 000 round and use fairly strong Payne's grey to pick out the dragon's eye and browline.

17 Work a buttery mix of Prussian blue and titanium white in around the dragon's head, to make a base layer of colour. Use the 3mm (⅛in) flat to apply the paint. While the paint is still wet, add some Payne's grey to the mix and blend in some shading on the head.

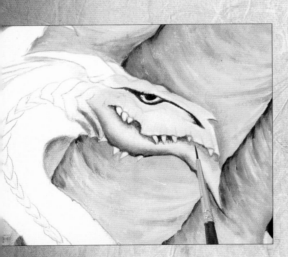

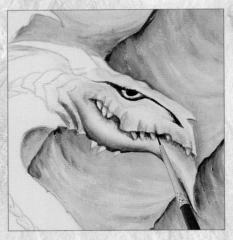

18 Switch back to the size 000 round for the tighter areas around the dragon's chin, then use a darker mix of Payne's grey to line the teeth and mouth. While the paint is still wet, blend the line down and away from the mouth a little with a damp brush.

19 Use dilute Payne's grey to add subtle shading to the top of the teeth where they emerge from under the upper jaw, then use the same mix to add texture to the upper jaw itself.

20 Continue to develop the modelling on the dragon's head using dilute Payne's grey and the two brushes. Finish the dragon's eye with a tiny touch of pure titanium white applied with the tip of the size 000 round.

21 Edge the bottom of the horns with Payne's grey and the size 000 round, then blend the paint upwards. Use the blade of the 3mm (⅛in) flat bright to apply titanium white at the top, then blend it downwards.

22 Edge the scales and spines immediately behind the head with Payne's grey and the size 000 round, then switch back to the 3mm (⅛in) flat to apply dilute Payne's grey over the area, keeping the darkest shades below the horns and behind the jaw.

23 Mix Prussian blue with titanium white and lay in a lighter-tinted basecoat over the top of the neck using the 3mm (⅛in) flat, keeping the lightest tint at the front of the dragon's neck.

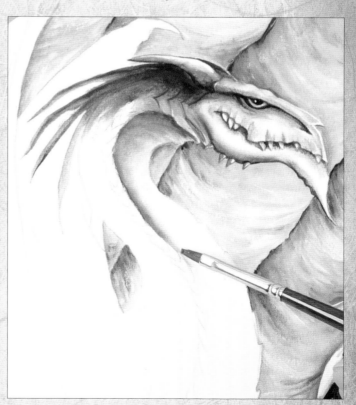

24 Extend the mix down the dragon's neck, then work dilute Payne's grey into the row of scales with the 3mm (⅛in) flat. Use short circular motions of the brush to get a clean blend.

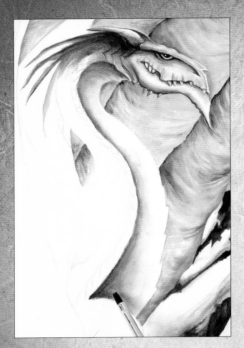

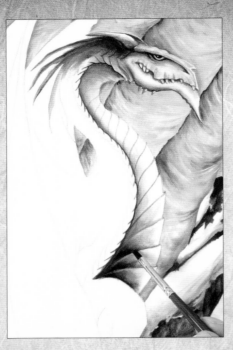

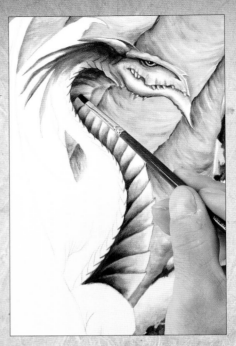

25 Work all the way down the neck, adding in pure titanium white on the forefront of the scales, and add in a dark area by the crook of the leg.

26 Edge the scales with dilute Payne's grey, applying the paint with the size 000 round brush. Switch to the 3mm (⅛in) flat and blend dilute Payne's grey in from the bottom left of each scale to the top, starting from the scale nearest the leg, as shown.

27 Work all of the frontal scales in this way.

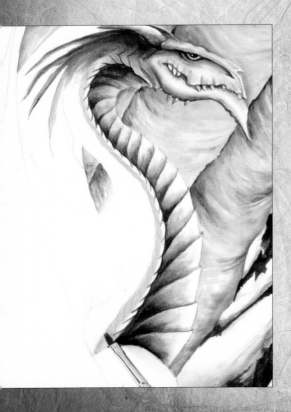

28 Use the 3mm (⅛in) brush to carefully paint a streak of a Prussian blue, titanium white and Payne's grey mix up the left-hand side of the central scales.

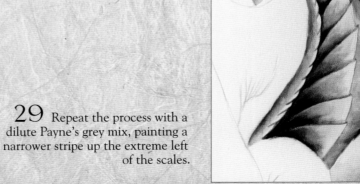

29 Repeat the process with a dilute Payne's grey mix, painting a narrower stripe up the extreme left of the scales.

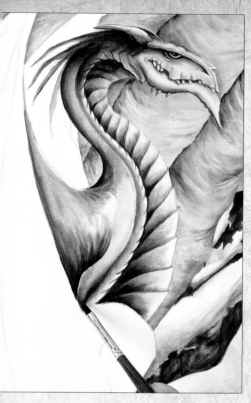

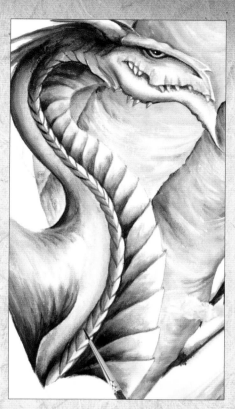

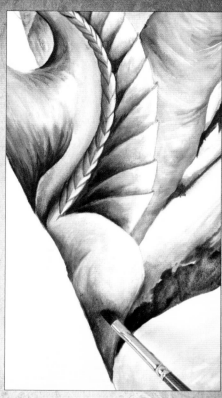

30 Paint a basecoat of a Prussian blue and titanium white mix over the dragon's body, blending in titanium white to the centre as a highlight and Payne's grey for shading.

31 Edge the central scales with Payne's grey and the size 000 round.

32 Lay in a basecoat of a titanium white and Prussian blue mix with the 3mm (⅛in) flat on the dragon's leg. Blend in dilute Payne's grey on the left and bottom for shading.

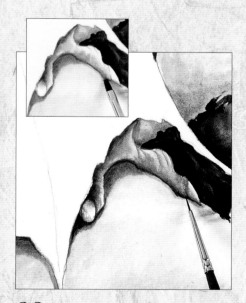

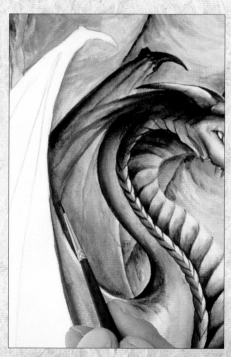

34 Paint in the dragon's rear wing, using the 3mm (⅛in) brush with a mix of titanium white, Payne's grey and a touch of Prussian blue. Working wet-in-wet, edge the back of the wing with Payne's grey, blending it inwards to create the shading and modelling on the wing. Starting from the claw, draw Payne's grey down with the size 000 round to mark the folds of the wing.

33 Still using the 3mm (⅛in) brush, lay in dilute Payne's grey on the foot (see inset), then lay in a mix of titanium white with a little Prussian blue to develop the modelling.

Tip
You can soften the lines of the tracing with an eraser if you feel it necessary.

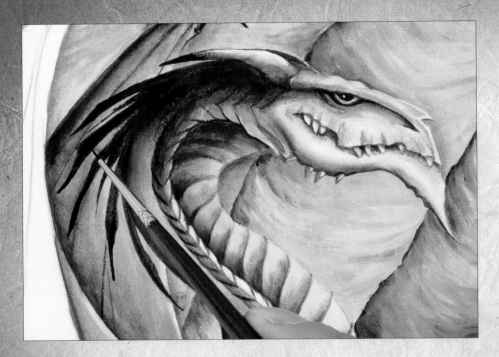

35 Paint the spines behind the head with pure Payne's grey and the size 000 round brush.

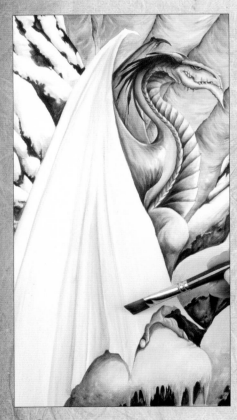

36 Swap to the 15mm (¾in) flat and use long sweeping brushstrokes to lay in a very pale mix of titanium white, Payne's grey and Prussian blue on the front wing.

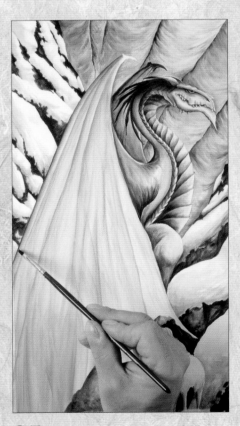

37 Continue to develop the wing, by layering on strokes of Payne's grey tinted with titanium white and Prussian blue in varying mixes. Follow the lines of the tracing. Swap to the 3mm (⅛in) flat and use the blade to draw a fine line of Payne's grey down the extreme rear edge.

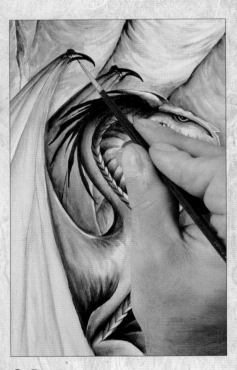

38 Add any final details, such as the claws, with Payne's grey, highlighting them with titanium white. Allow the paint to dry and remove the masking tape to finish.

Opposite

The finished picture, reduced in size.

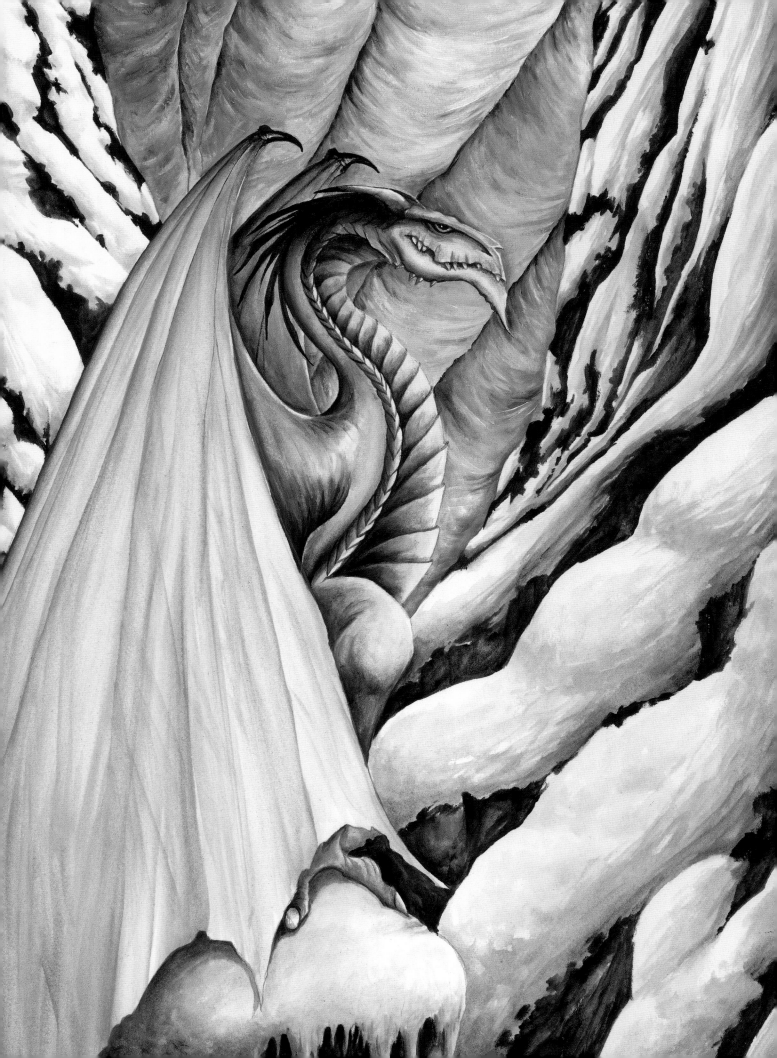

Index

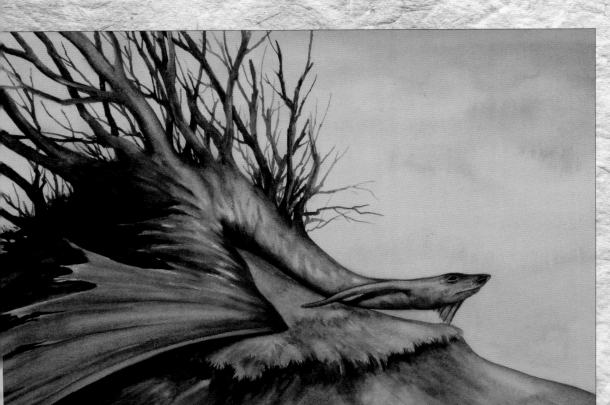

Hillside Dragon
30.5 x 20.5cm (12 x 8in)

This great beast is so old, it has become part of the landscape itself.